Who's Who in
Modern Japanese Prints

Who's Who in

MODERN JAPANESE PRINTS

by *Frances Blakemore*

New York · Weatherhill · *Tokyo*

First edition, 1975
Third printing, 1976

Published by John Weatherhill, Inc., of New York and Tokyo, with edi-
torial offices at 7-6-13 Roppongi, Minato-ku, Tokyo 106. Protected by
copyright under terms of the International Copyright Union; all rights
reserved. Printed and first published in Japan.

Library of Congress Cataloging in Publication Data: Blakemore, Frances. /
Who's who in modern Japanese prints. / Includes index. / 1. Printmakers—
Japan—Biography. / I. Title. / NE771.B55 / 769'.92'2[B] / 74-28174 /
ISBN 0-8348-0101-9

Contents

Although in the last twenty years a number of books have been written on contemporary Japanese graphics and although several of these, such as those by Oliver Statler, Michiaki Kawakita, and James Michener, are works of art in themselves, they are all too expensive, too specialized, too technical for the average need, or too out of date, if not actually out of print. There is a growing demand for a book that can serve as a single reference: to give a large, representative listing of print artists now or recently active in Japan, giving in each case the artist's age and principal media and discussing his output, participation, and development in terms that a person with an interest in modern prints and graphics can readily understand. There are a very few regrettable omissions of outstanding artists, as it proved impossible to obtain necessary photographs or information before this book went to press.

Furthermore, no reasonably complete compilation of both independent and organized Japanese graphic artists exists, even in the Japanese language. The compilation offered here as an appendix is the result of searching through countless sources in both Japanese and English: catalogues, membership rolls of print associations, and listings of one-man shows of independent artists found in back numbers of many art periodicals. Japanese-language questionnaires were mailed to some five hundred graphic artists whose addresses could be learned. Some questionnaires were returned undelivered, some were not answered, and a few artists who had not received the original mailing were added at a later date; but even with these minor problems, the number of replies was extremely gratifying.

Since this book would become too unwieldy for easy reference if I attempted to discuss and illustrate the works of every person who ever made and sold a print in Japan, I decided to choose a cross section of one hundred and five artists. A few represent the earliest flowering of the modern Japanese print and are still producing, but the majority are artists who began their careers in the last decade or so. The selection had to be made on an impartial basis, not simply according to my own judgment. To show the diversity in current materials and perceptions, a balance in techniques and styles had to be presented. Therefore, the questionnaire gave each artist the opportunity to nominate five colleagues whom he thought should be

included here. These results were tabulated and used as guidelines. Final selection also took into account a recent poll of fourteen prominent Japanese critics, who chose among a representative group of contemporary printmakers.

The approach I have taken in the text is neither that of reporter nor that of critic. More is said of the art than of the artist, and no attempt is made to rate these incomparable creators one against another. That is left to the reader, with the aid of the illustrations. Hopefully, readers will have an opportunity to see the actual prints and draw their own conclusions: after all, art appreciation is—and should be—a very personal experience.

Although many of the artists treated in this book have long been friends of mine, the text is not the result of interviewing individual artists. A reference book based on such questioning would be unbalanced—some artists have had rich experience in study and travel, others none at all; some are articulate and love to philosophize, while others are silent, in the belief that in art, graphic communication is the utmost test and that this alone should suffice.

This text reveals instead how one artist looks at the work of another artist. While my interpretation may not always reflect exactly what the Japanese artist himself feels or intends viewers to see, it does suggest that viewers may—indeed should—exercise the same privilege in their own experience of an artist's work. I hope this perhaps unorthodox statement encourages readers to become active viewers, to look and feel, to use their own powers of imagination, and to use their own judgment, for then they will have taken an important step toward enjoying art and savoring its lasting appeal.

I am grateful to the following sources for illustrations of the work of the artists indicated: Cimaise's S, Kamakura (Ado Sato); Murakami Gallery, Tokyo (Kiyoshi Saito); Nantenshi Gallery, Tokyo (Ay-O and Masuo Ikeda); National Museum of Modern Art, Tokyo (Risaburo Kimura); Tokyo Gallery, Tokyo (Kazumasa Nagai and Shinjiro Okamoto); Yamada Gallery, Kyoto (Ryohei Tanaka); Mas Yonemura Collection, San Francisco (Shiko Munakata); and Yoseido Gallery, Tokyo (Takeshi Hara, Tomio Kinoshita, Rokushu Mizufune, and Jun'ichiro Sekino). Most of the other photographs are from the Franell Gallery, Tokyo, or from my own collection.

My special thanks go to Weatherhill's editorial staff, particularly Meredith Weatherby and Rebecca Davis, for encouragement, helpful guidance, patience, and good judgment.

Much credit is due to my associates at Franell Gallery for the

8 tedious work of translation, getting in touch with the artists, and collecting data for the appendix.

Finally, I am greatly indebted to T.L.B.

The Japanese Print:
A Historical Survey

Today, Japanese prints are admired the world over, and the artists
who make them are themselves often internationally known. At ex-
hibitions and invitational shows, at worldwide print biennials, and
in competition with print masters from the West, once-strange
Japanese names have become familiar: Munakata, Saito, Nakayama,
Hoshi, Mori, Yoshida, Ay-O, to mention but a few. Who can de-
scribe the print medium in the current century without referring to
these names? To treat these artists as solely Japanese is to distort
their essential universality. And yet, to deny their intrinsic Japanese
nature is to miss something equally significant: the aesthetic sensi-
bility that has developed in this tiny archipelago over thousands of
years and that can be admired abroad.

Los Angeles, São Paulo, and Rome are now but a jet hop from
Tokyo. Even the struggling young artist can afford the air postage
to participate in shows abroad. The chance to gain recognition acts
as an enormous stimulus to creation. A few prints in an international
competition can be followed by a group show, a one-man show, and
an opportunity to study and grow in another country.

Except for a trickle that had come through Portuguese and Dutch
traders, little visual documentation of this unique country that we
call Japan had made its way to the West until Perry's arrival in
1853. With the opening of Japan to foreign shipping, the color print
found its way to the West in great numbers, to reveal the strange
and exotic customs of this alien land. This art form, which had been
in existence for roughly two hundred years, was first introduced by
James McNeill Whistler to the London Pre-Raphaelites in 1859.

By this time the golden age of the *ukiyo-e* print was on the decline
and with it the highly idealistic imagery and abstraction not evident
in art in the West. Utamaro was dead. Only a few artists of first-rate
talent developed to take the place of such masters as Harunobu,
Kiyonaga, and Sharaku. The great day of the renaissance of landscape
art under the genius of Hokusai and Hiroshige was over.

Almost a century passed before a visual substitute for the color
print—the color photo—came into common use following World
War II. Fortunately for the rest of the world, the ukiyo-e still existed

in great numbers and in the interim was prolifically reprinted, many times from the sturdy original blocks, thus filling the gap. The imagery of the ukiyo-e was fixed in the eyes of the world as representative of Japan. Even today many Westerners identify the "Japanese print" only in terms of the classical ukiyo-e color print.

The artistic integrity of modern Japanese prints was not recognized until after 1945. These works were conceived and executed by the artist himself, unlike the ukiyo-e print, which had been a collective result of the efforts of artist, cutter, and printer. The modern *sosaku hanga-ka* (creative print artists) retained the media of wood and watercolor developed by their predecessors, since other techniques were practically unknown in Japan. The beginnings of the modern print movement early in the century were snuffed out by war, and except for isolated cliques of courageous devotees, printmaking did not develop into a movement until the 1950s—if a movement may be defined as a large number of people devoting the major part of their activity to creating, organizing, setting standards, and exhibiting.

Ironically, the devastating effects of war proved to be a dramatic turning point in the artist's development. The shackles of convention were broken and he was forced to be self-reliant. Scarcity of shelter and of artistic materials gave the printmaker an edge over other artists. Some sculptors and painters turned to the more practical art of printmaking. This medium required only a few feet of working space, and with ingenuity a few tools could be fashioned and paper and ink obtained. Wood for blocks could be scrounged. It is said that out of desperation for good wood even ukiyo-e blocks were planed down and reused. But it is more reasonable to assume that they were too cumbersome to evacuate during the war and, instead, deteriorated through neglect in partially destroyed storehouses or were lost in fires. Still, the fact remains that Japanese artists turned to the print medium when little else was possible.

Forced self-reliance not only sowed the seeds of creativity but changed the need for rigid discipline in art training, which in China and Japan had for centuries been thought essential. No longer was it imperative to follow the "way of the master" until styles and techniques were deeply ingrained. The artist was now free to improvise, to develop new forms of expression, to master new skills, to discover new materials. As *shina* and *rawan* plywood became available he expanded the area of his vision far beyond the physical limitations originally set by the small-sized cherry-wood block.

The burgeoning of modern print art can be attributed to a new audience—the thousands upon thousands of Westerners who wandered through the land during the occupation. These new prints, never fully accepted by the Japanese, were popular with the foreigners and sales flourished. Modern prints were inexpensive and easy to appreciate and were therefore preferred over the more traditional ink painting and ukiyo-e. The poetic landscape, the decorative kimono, and the elaborate hair style of the ukiyo-e had all but disappeared and did not represent the Japan known to the newcomer.

The enthusiasm for new print methods developed with the increase of Japanese students abroad. Etching and lithography, known only to a privileged few in prewar days, became popular. Students learned that the American silkscreen method was nothing more than that commonly used for centuries by Japanese textile dyers but never applied to print art. The brittle brown paper impregnated with persimmon juice used by the Japanese dyers was found easier to cut than and superior to the papers then in use abroad. With the appearance of nylon netting a quick substitute for the old, time-consuming art of lacing silk thread across the stencil, to hold the bits of paper together, came into use, and with it the popularity of the Japanese stencil was established. As demonstrated in Ronald G. Robertson's excellent technical book, *Contemporary Printmaking in Japan* (New York: Crown, 1965), experimentation grew: leaves, cloth, and almost anything else with an interesting texture were glued to blocks; plastics, chemicals, and photographic film further expanded the scope of the graphic arts. Media were mixed in countless combinations, and the print boom reached new heights.

Expression, too, took new directions, from the literal to the abstract, from fantasy to symbolism, from the calligraphic to the minimal: each artist developed a way of his own. Today, as competition increases, changes are inevitable and the Japanese, like artists the world over, are still seeking the new and can be expected to continue to do so. Some artists openly state that they do not want a national identity but wish to follow world trends and compete on this basis. Some innocently fail to abandon their identity even though they try. Others rely proudly on things Japanese.

It is hoped the following pages will show the far-reaching diversity of materials and perceptions in the modern Japanese print. What cannot be shown is the extent to which they are related by one universal element: paper. Japan is indisputably the home of the finest handmade paper in the world, far more varied and appealing than

that found in either Europe or America. Undoubtedly one of the aspects of Japanese prints that Westerners find most fascinating is the paper itself: absorbent, light, velvety warm. The paper enhances the prints and also serves as an inspiration. It is the paper, not the wood, copper, stone, or ink, that is the essential tool of the print artist. The genius of Japan's papermakers is today best seen in the prints of Japan's finest artists.

In this jet age, when cultures blend and melt away, when identities merge and disappear, when everything from food to travel has been standardized, it is reassuring to look at an original print and know that some person has carried his own vision to fruition. The graphic is the medium of modern man, for it utilizes the elements of everyday life to create a personal world and to project personal visions into the age of the instant image.

Who's Who in
Modern Japanese Prints

Akiyama, Iwao

Born: 1921
Medium: woodblock

A spot of red on a black-and-white woodcut is a pretty sure clue that the artist is Akiyama. To make doubly sure, look for the Japanese seal pressed onto the print somewhere along the border. These idiosyncratic identifying details indicate Akiyama's subtle sense of humor. Other expressions of his humor are the animals that appear in edition after edition of his prints—harmless-looking leopards, friendly cattle, crows.

There is something appealingly rough and unfinished about these prints, first in their use of folk-craft paper, spotted with bits of the outer bark of the mulberry shrub, and second in the rough edges of the animals. This is clearly an intentional avoidance of elegant refinement, which at times fools the eye, making leaves seem to quiver and animals emerge from camouflaging backgrounds.

Tiger Cubs. 17 × 12¼ in.

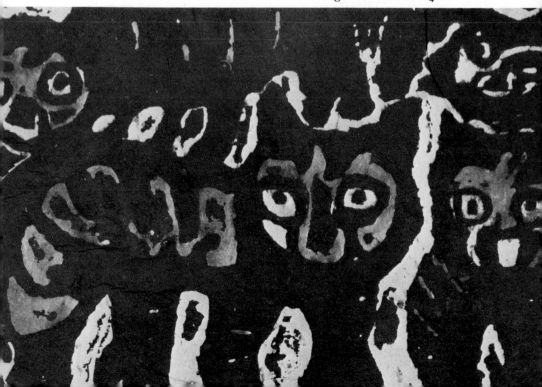

Young Bull and Girl. 6×11 in.

Akiyama, Taikei

Born: 1927
Medium: woodblock

These prints play tricks with figure and background relationships. Continuous forms share lines so that there are more people or cows or hands than at first seemed to be showing. This would be only a game were it not for the arrangement that prevents the viewer's being really fooled: following the white images forces the others into visibility. The result is an exercise in learning to see.

Once this process takes hold, remarkable revelations can occur: details that seem entirely nonsensical suddenly come to life. Objects are placed much closer to one another than they ever are in nature. But that may be just the point, for how much do we overlook in perceiving the relationships between figures and background? Perhaps we should renovate our ways of seeing.

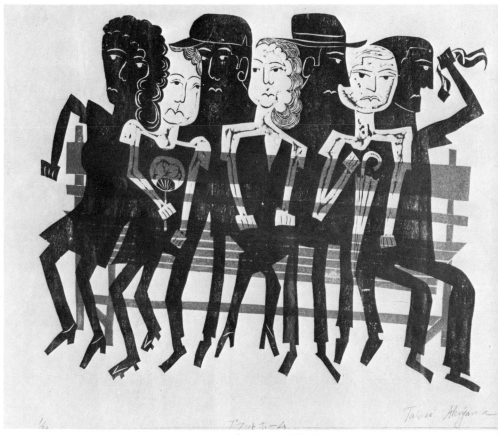

Platform. 29½ × 23½ in.

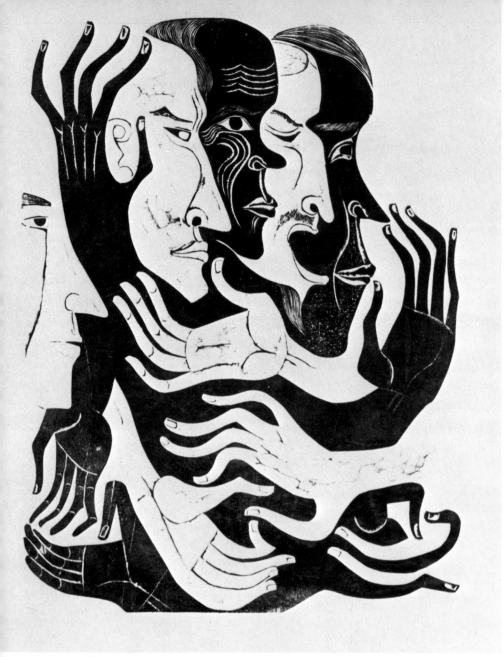

Masks. $23\frac{1}{2} \times 31\frac{1}{2}$ in.

A Cattle Show. $35\frac{1}{2} \times 47\frac{1}{4}$ in. ▷

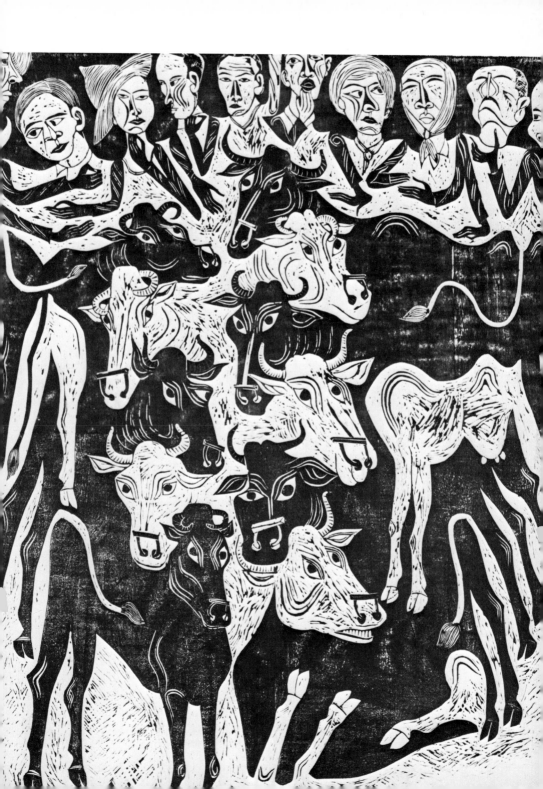

Amano, Kazumi

Born: 1927
Medium: woodblock

Disdaining the easy way, Amano undertakes the most challenging formulas for composing his prints. Linear forms are combined with curves and sharp angles; flat treatment is blended with shaded areas to form new images. Unlimited too in color application, warm and cool, pale and intense unite in a forceful abstract pattern. In some works still another element, that of deep embossing of the pulpy handmade paper, emphasizes a form or carries subtle lines into the border.

Amano has exhibited in major international biennials for years and built up a deserved reputation for himself. Perhaps his early participation helped call attention to the quality of work being produced by his countrymen. Although at one time he studied under the master Shiko Munakata, no similarity between the two remains except the strength of their presentation.

Plan-Color B. 17¾ × 23⅝ in.

Self-portrait (Mirror). 18 × 24 in. ▷

Amano, Kunihiro

Born: 1929
Medium: woodblock

These prints are filled to the very edges with a bold mixture of vivid colors and stark black that combine with great intensity. The lower edges are finished in double scallops whose shape leads to a center of interest: a sphere composed of concentric circles printed in prismatic colors. From this center a row of dots, sometimes embossed, decreases in size as it approaches the bottom edge of the print.

Each Amano woodcut is a very personal expression consisting of voluntarily limited shapes. The contrast between the simple, rounded forms and the intense color projects great depth of emotion. Some people have found sexual symbolism in these abstractions, and indeed the erotic implications of the imagery cannot be discounted.

Imagination 48. $24\frac{1}{2} \times 25$ in.

◁ *Imagination 29.* $24\frac{1}{2} \times 25$ in.

Ato, Sengai

Born: 1929
Medium: paper screen

The mandala is a schematized prayer wheel that represents the universe. Ato's mandalas contain many traditional Buddhist symbols: the flame, Sanskrit letters, a simplified head of the Buddha hidden within the vivid colors of the wheel's center.

The artist is a Buddhist priest, but many of his admirers are Westerners of a variety of faiths. In fact, he was chosen by Time, Inc., as one of fifteen rising Japanese artists whose works were reproduced in domestic and overseas editions of *Time*, *Life*, and *Fortune* magazines.

Perhaps the reason his appeal is not limited is that his works can be seen simply in abstract terms. Indeed, some of his wheels are only circles made with a single stroke of a brush, as in Zen painting. This simplicity distinguishes Ato's mandalas from the earlier Buddhist wheels brought to Japan from Southeast Asia. Simplicity like Sengai Ato's may be Japan's contribution to Buddhism, and to modern art as well.

Mandala. 17½ × 19½ in.

Pilgrims. 15 × 18 in.

Nirin Mandala. 15×21 in.

26 **Ay-O** If a trademark battle ever develops over the rain-
Born: 1931 bow, Ay-O will have a pretty strong claim to
Media: etching, ownership. Once just an arc in the sky and a direc-
silkscreen tion finder to a hidden pot of gold, it has been
transformed in Ay-O's gentle hands into a way of
seeing. His rainbows become waves or human figures or gamboling
animals. As if by magic, they conform to any shape, develop sculp-
tural substance, or freely move back and forth in the print. What is
most remarkable, perhaps, is that color, line, subject matter, and
intensity are really fused into a single element, the individual prints
being but aspects of a process that turns objects and surfaces into
props for a perpetual happening.

Applying his rainbow to three-dimensional objects for display and
for fun, it is through the process of the silk screen that his image
shows to best advantage. Collectors who obtained his *Nashville
Skyline* series (1971) will cherish it for its amusing folksiness, its
clever combination of brown etched details, and its twenty-four col-
ors, possibly inspired by exposure to American lore when he taught
at the University of Kentucky in 1968 and 1969. With the issue of
each new Ay-O print a new innovation can be expected with no sac-
rifice of beauty or perfection in register—an impressive accomplish-
ment.

Goodbye Mr. Gauguin. 84½ × 56 in.

Animals A. $29 \times 21\frac{1}{2}$ in.

Rainbow Night C. $23 \times 14\frac{3}{4}$ in.

Azechi, Umetaro

Born: 1902
Medium: woodblock

Have you ever looked some animal straight in the eye and felt a shiver of communication that defies logical explanation? You get the same sort of feeling when you look at the staring eyes of Azechi's primitively charming mountain folk. Azechi points out similarities in man and bird by using the same bold stripes to represent the beards of his mountain men and the patterned feathers of his quail. Blues and greens in all their variations dominate his works, used in icy banks that reflect the tangy color of evergreens, the cold purple and blue shadows of high places, the cloudless infinity of pure skies.

Despite their repetitiousness, one never becomes bored with Azechi's prints. Their humor delights. They can be called primitive, but their primitiveness is the bold statement of a mature artist, not the accidental simplicity of a child.

Azechi is recognized as an articulate philosopher and author of a number of illustrated books and magazine articles relating to the serenity he derives from escape to lonely mountains. It is fortunate for a man of Azechi's sensitivity that he has known a time when such escape was still possible.

Man with Rope. $8\frac{1}{2} \times 13\frac{1}{2}$ in. ▷

Mountain Bird. $8\frac{1}{4} \times 13$ in.

With a Bird. $6\frac{1}{2} \times 10\frac{3}{4}$ in.

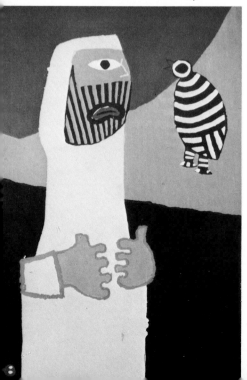

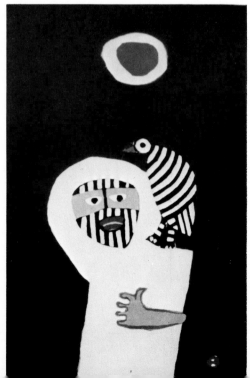

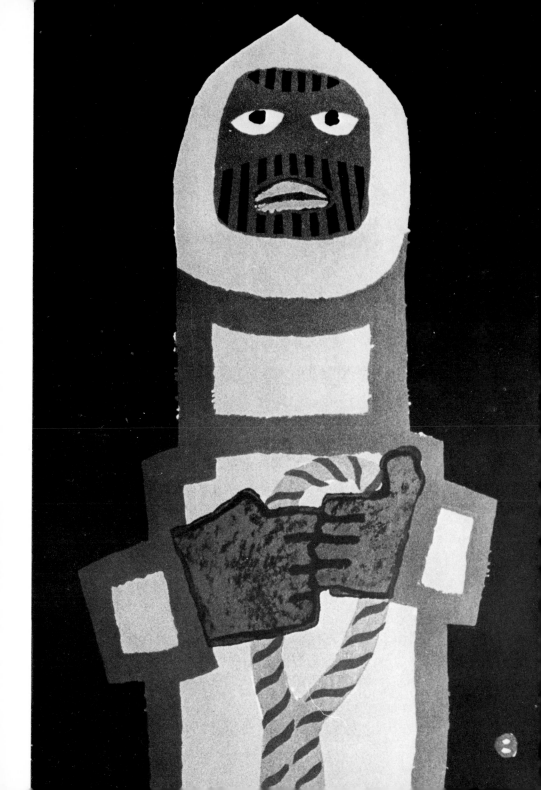

Baba, Kashio

Born: 1927
Medium: lithograph

The gaudy colors and bubbly gaiety of these prints are intentionally deceptive. Look closely, and the giddy childishness chills to frightening violence. The atmosphere of a circus sideshow masks the seriousness of the subject matter. In *Show*, the clown's painted face is wrinkled in a frown, as is that of the sad ringmaster beside him. The singing fan-dancers seem to be writhing in pain. The geisha head between them has its tongue out derisively. As for *Shooting*, the tiger-faced ticket taker looks downright grisly, while the simple legend "10 shots" is ominous.

The prints are finely detailed so that each element stands out clearly, expressing its own portion of the satirically bitter message.

Show. $17 \times 14\frac{1}{2}$ in.

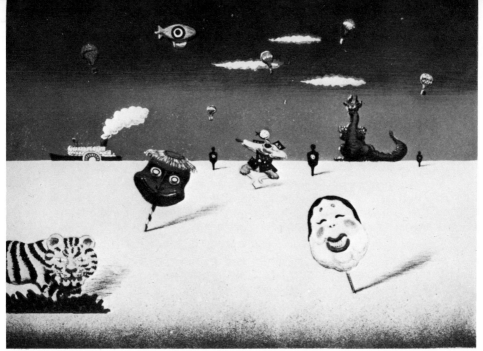

Dolls. 20½ × 16 in.

Shooting. 21½ × 18 in.

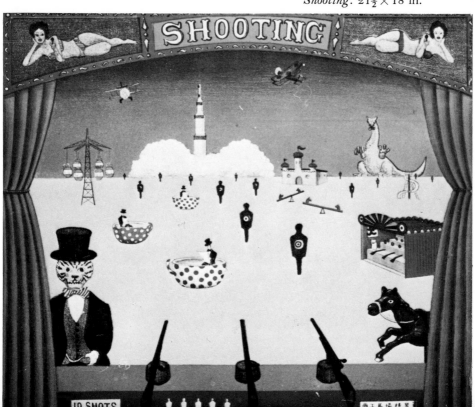

Fukazawa, Shiro

Born: 1907
Medium: silkscreen

Many but not all of Fukazawa's serigraphs contain images made familiar by ukiyo-e woodblock artists centuries ago —the faces of Kabuki actors in various roles. They are used decoratively by this contemporary artist, delicately humanizing a basic geometric pattern. Many of the faces seen here are so well known to both Japanese and foreign print enthusiasts that even a part of one can be recognized instantly. Several other Kabuki elements can be found in these prints: the traditional striped stage curtain appears in various forms; and the throbbing repetition of bright colors imitates, to me at least, the rapid crescendo beat of the wooden clappers at the start of a Kabuki performance. This is not the old Japan, however, but the new Japan that contains the old sometimes intact, sometimes fragmented.

Enlargement C. 9½ × 9¼ in.

Paper Monument of Patient Card B. $10 \times 5\frac{1}{8}$ in.

Sharaku and I 727–B. $15 \times 13\frac{1}{2}$ in.

Mirror-B. 20 × 28 in.

Fukita, Fumiaki

Born: 1926
Medium: woodblock

Dots appear often in Fukita's prints— clustered dots, dots in a radial pattern, dots that pinpoint an explosion. However rendered, they seem to be a part of some exciting space phenomenon extending into infinity—into depths that might be measured in light years.

Bursting patterns and radial forms are familiar to the Japanese. Their unmatched fireworks in all their glory and color are sometimes called chrysanthemums of the sky. A stylized version of this flower was adopted as an emblem of the emperor of Japan in the twelfth century. It is natural for Fukita to retain this concept in his prints year after year and have followers who appreciate it. Soft Japanese paper enhances the depth of Fukita's skies as much as his favorite deep blue tones.

Flower and Star. $11\frac{1}{2} \times 16$ in.

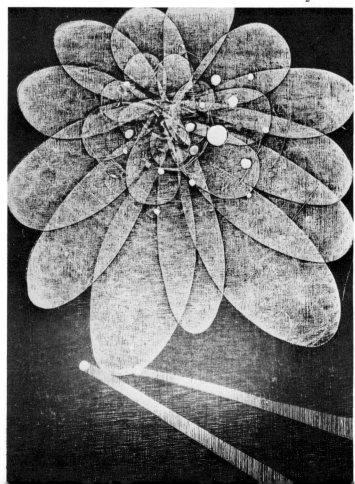

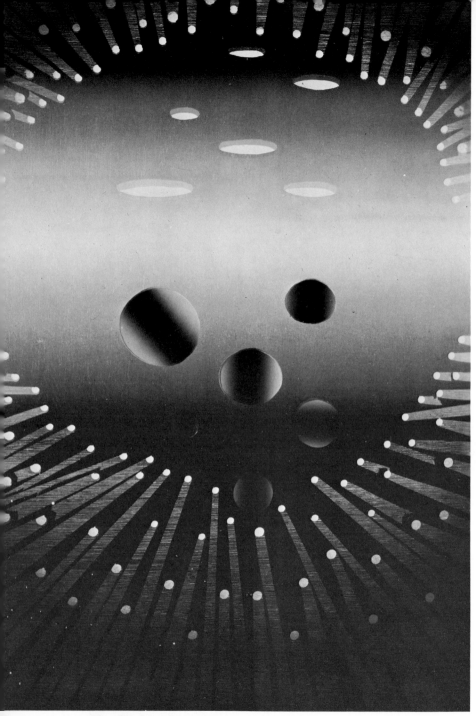

Blue World. $24\frac{3}{8} \times 36\frac{1}{4}$ in.

Funasaka, Yoshisuke

Born: 1939
Media: woodblock,
silkscreen

Funasaka has been experimenting with the lemon motif with great variety and imagination since 1960. It appears in groups, singly, as the outline of a breast, or as an element in an abstract composition. The familiar yellow oval, always normal in size, may contrast starkly with red-orange or black backgrounds or may almost disappear in a less dominant role.

Long ago, Funasaka said of the lemon: "I like the taste, I like the smell, I like the color—it represents freshness." Whether his experiments involve raised and perforated surfaces, combinations of delicate woodblocks and flat silkscreened areas, dark or pale images, a Funasaka print manages to maintain, above all, that admirable quality—freshness.

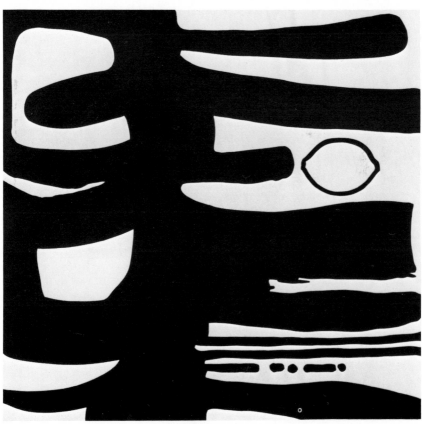

Lemon Black and White Series. $17\frac{1}{2} \times 17$ in.

Lemon-340. $17 \times 21\frac{1}{2}$ in.

Hara, Takeshi

Born: 1942
Media: etching,
lithograph, silkscreen

The movement of light can be depicted without reference to recognizable forms by being represented as its own form, having its own weight, substance, and depth.

The paths of light that Hara projects onto paper have a chameleonlike quality, changing in intensity and hue as they move in a continuous crisscrossing streak from corner to corner. The constant play between light value and linear movement builds up a fascinating expectancy that makes these works interesting.

Hara has achieved the ultimate in nonobjectivity in creating a formula unrelated to physical truths of everyday life—a formula on which to speculate and to enjoy for its own qualities. In a sense, these prints reproach the rigidity of the camera, which can only record possible images.

Graduation 73-4. $26 \times 18\frac{1}{2}$ in.

No Focus 73-1. 26 × 18 in.

◁ *Graduation* 72-3. 18 × 26 in.

Horie, Ryoichi

Born: 1943
Medium: woodblock

Symmetry is the surest means of unifying a diverse composition. Simplified abstract shapes, reversed and repeated, become familiar and logical. Horie's round shapes tend to balance his powerful stripes, creating strong patterns that are interesting yet easy to grasp. The subtlety lies in the reversals. Sometimes the curved portions appear to contain the white lines, sometimes to be contained by them, but on examination it is clear that a symbiotic relationship exists among the parts, which are held together by equal tensions in all areas.

In his earlier work, Horie preferred hard colors and rich variations of muted tones. More recently, however, greater contrast has been introduced and some areas are left completely blank, a bold course for any printmaker. One of the advantages of adhering to a single line of development, as Horie has done, is that confidence is achieved, and with it boldness of execution and expression.

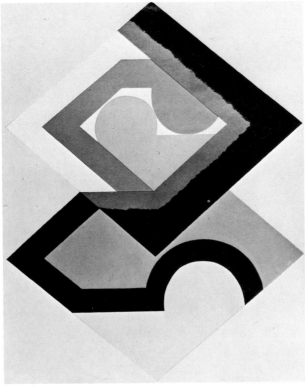

Work 72-14. $22\frac{3}{4} \times 29\frac{1}{8}$ in.

Work 72-8. $22\frac{3}{4} \times 29\frac{1}{8}$ in. ▷

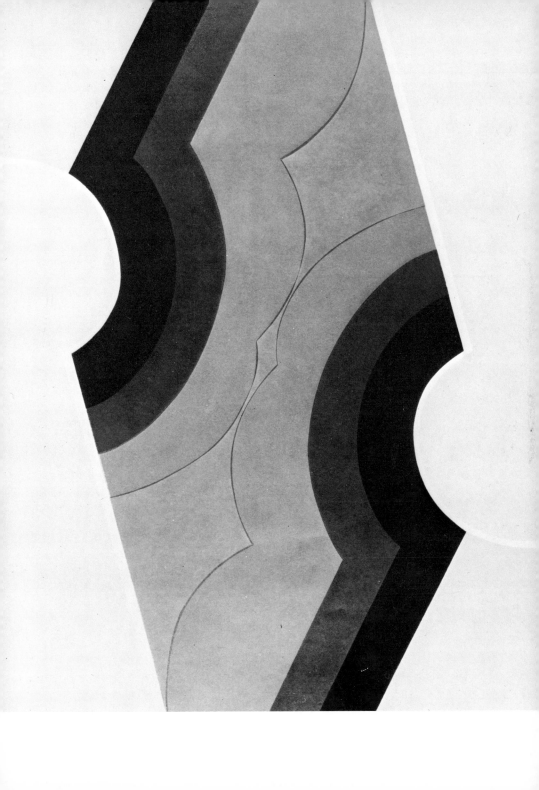

Hoshi, Joichi

Born: 1913
Medium: wood engraving

Hoshi's art career has gone through several transformations, changes not uncommon to careers spanning several decades. Fifteen years ago he contrived delightful abstracts by carving the actual grain-patterns he observed in special blocks, then printing them in overlapping colors and relationships.

Hoshi's current interest is still in wood as a medium, but now he engraves the intricate patterns of leafless trees with a refinement and delicacy never required of abstract subjects. In a realism faithful to nature, each branch, each twig accepts the light and shadows cast from the sky. However well executed this is, it is yet another factor that distinguishes these prints—the sometimes mystical, sometimes poetic moods that the artist instills through colors combined with metallics. A red tree may be shown against a sky of gold leaf, toned with the finest distant lines; a dozen winter elms lean across a background of silver streaks, with a glistening foreground having a pearly substance. While Hoshi's trees are Western in rendition, their emblazoned glory and the luminosity of the background materials recall the magnificent folding screens that graced the courts of Japan's feudal lords.

Red Tree. $21\frac{5}{8} \times 16\frac{1}{2}$ in.

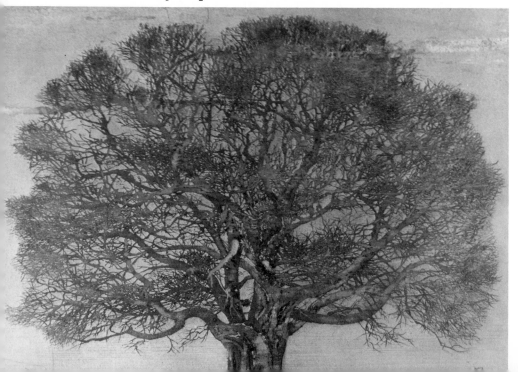

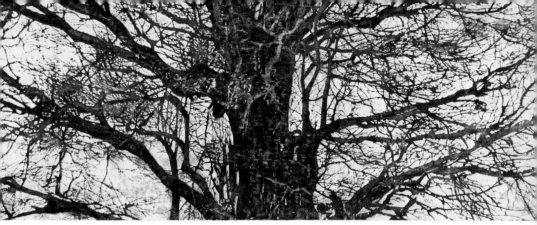

Trunk and Branches. $34 \times 13\frac{3}{4}$ in.

Morning. $16\frac{1}{2} \times 22\frac{1}{4}$ in.

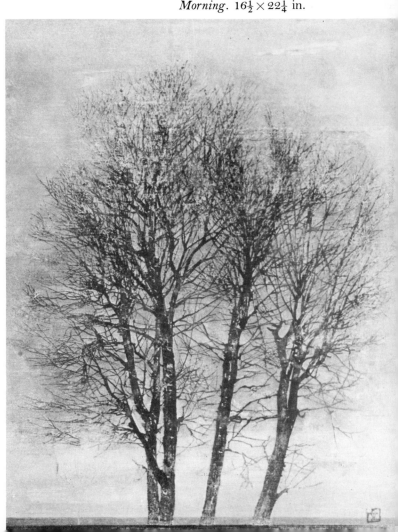

Ichinose, Masako

Born: 1937
Medium: etching

Abstract etching is a particularly expressive medium, especially when the artist has the expert control to maintain consistent standards while working for a variety of effects whether in mezzotint or dry-point techniques. Ichinose has a talent for re-creating subtle effects seen in nature—the shadowy depths of caves, the messages written in the erosion of stones.

In these prints a velvety richness is achieved by placing soft greens and Prussian blues against smoky rose tints in evocative combinations. Occasionally a totally flat segment is inserted for startling contrast with painstakingly worked dominant areas. If the accidents of method seem to play a role in the intricate texturing, it must be remembered that it takes an artist's eye to evaluate such effects and an artist's hand to weld them into a truly artistic final form.

Aventure Fantagique. 14×17 in.

Nouveau Départ. $18 \times 22\frac{1}{2}$ in.

◁ *Work F.* 15×13 in.

Ikeda, Masuo

Born: 1934
Media: woodblock, lithograph, silkscreen, etching

Ikeda's graphics appeal simultaneously on the intellectual and the erotic levels. A mature craftsman and meticulous researcher, his works reveal a debt to past artists and a confident originality. As a result, his reputation at home and abroad has skyrocketed in recent years.

Sometimes the prints reveal a fascination with classical philosophy or poetic themes; sometimes they show a compulsive interest in the female form that some may find offensive but to others is an honest revelation, for what subject is more enlightening than the images a graphic artist carries around in his head? In either case, his interests are clearly shared, for Ikeda has received prizes in major competitions in Paris, Ljubljana, Krakow, Venice, New York, and, it seems, anywhere else there are worthwhile print awards to be won. In Tokyo, his rare exhibitions are eagerly awaited, for they invariably introduce new facets of his bold and inventive mind.

I Continue Sleeping. $20\frac{7}{8} \times 24\frac{1}{2}$ in.

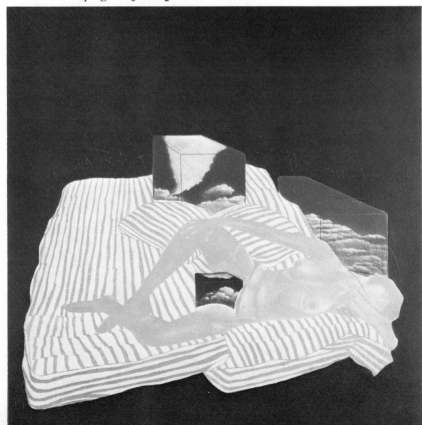

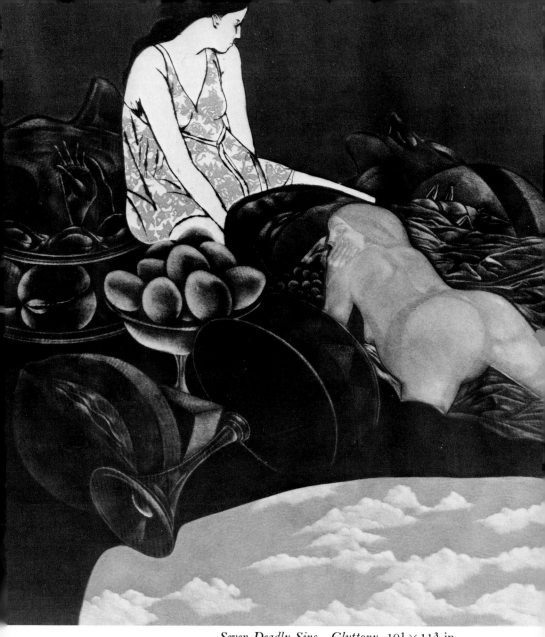

Seven Deadly Sins—Gluttony. $10\frac{1}{2} \times 11\frac{3}{4}$ in.

Ikeda, Shuzo

Born: 1922
Medium: woodblock

The small child's enchantment with nature is one major area of this artist's interest. Others are sacred stone images, native dolls, and young women and children in floral settings. The artist's treatment of a child's relationship to a butterfly, a bird, a dragonfly reveals tenderness and sympathy.

The child's appreciation of nature, as expressed in *Lady Bug*, where a tiny insect is held delicately between thumb and forefinger, is not so much a recognition of today's ecological problems as a recollection of traditional Japanese attitudes. The prints have a naturalness that expresses love of the outdoors. The woodblocks themselves are carefully textured.

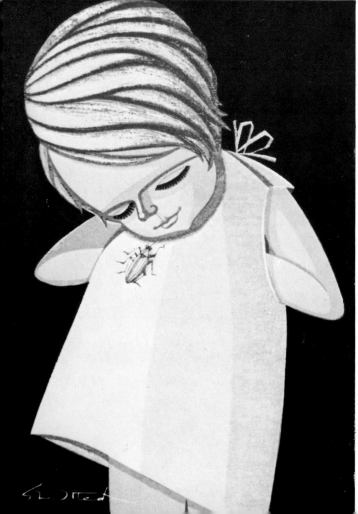

Insect. $9\frac{1}{2} \times 14\frac{1}{4}$ in.

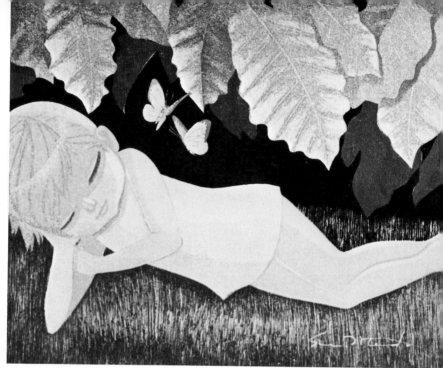

Kichiyo. $12\frac{1}{2} \times 10\frac{1}{2}$ in.

Red Fruit. $12\frac{1}{2} \times 11$ in.

Inagaki, Tomoo

Born: 1902
Medium: woodblock

Labeled for years as an artist who restricts his subjects to cats, Inagaki's talent has saved his perennial subject from ever becoming dull. Using cat forms as an inspiration for a simplified sectioned design, combined with the ever-changing character of his subjects, he applies his colors and values with the same logic as an abstract artist.

There is humor in Inagaki's exaggeration of feline characteristics —the wise quizzical eyes, the perfect posture, the rhythmic groupings—that keeps these stylized prints from ever being repetitious. Purely realistic treatment would have reduced these sophisticated expressions to sentimental ineffectiveness.

Couple of Cats. 16 × 21 in.

Four Cats. 16 × 22½ in. ▷

52

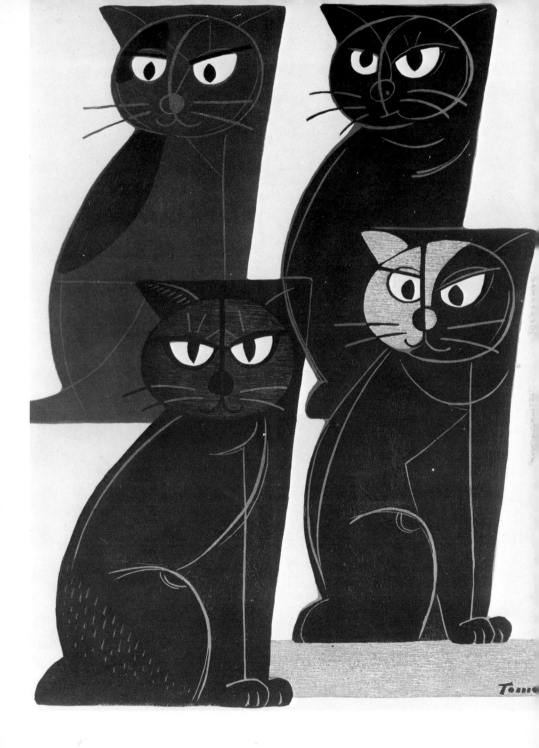

Iwami, Reika

Born: 1927
Medium: woodblock

Iwami is a rarity among woman woodblock artists in her avoidance of color. Solid, pure blacks are blended with finely textured grays and some metallic gold. Large full moons often dominate the prints, with rocketlike golden thrusts piercing them in bold curves. Wavelike patterns like communication symbols sometimes bisect the circles. Sprinklings of powdered mica over the white areas give the impression of windblown sand. In the absence of brilliant colors, form and texture are strongly evident.

Technically as well as artistically, Iwami is a polished professional. Driven by a powerful desire for expression, she undertakes each step of the printing process herself—from the cutting of the blocks to the inking and the rubbing of the paper. Especially difficult is the embossing, which requires great physical strength.

Iwami's devotion to her work is apparent to all who see it. The finished prints have a wholeness that cannot be matched by ordinary production techniques.

A student of the great Koshiro Onchi, she studied art at Bunka Gakuin in Tokyo.

Song of Water. 11 × 16 in.

Zero in Water G. 21 × 31 in. ▷

Iwashita, Yo

Born: 1917
Medium: Japanese stencil

The emphasis in these prints is on folksiness, authenticity. But a further emphasis, perhaps equally important, is placed on humor, lightness of character expressed through soft colors, decorative designs, and cleverly realized relationships.

Iwashita uses the stencil method originated by Japanese dyers centuries ago as a means of transferring patterns to cloth. Originally the stencil was cut through two pieces of paper, which were separated and crisscrossed with silk thread, then pasted together. The fragile design, thus strengthened, held up under heavy use. Now fine nylon netting is lacquered to a single sheet. The old method of treating the paper with the astringent juice of the persimmon to make it brittle for cutting is still practiced.

In keeping with the tradition of his medium, Iwashita's folk-characters wear old stencil-dyed patterns, and again the lacy waves or botanical forms adapted from old textile designs serve as background lines that unite Iwashita's subjects.

Noah's Ark. $15\frac{3}{4} \times 12\frac{1}{2}$ in.

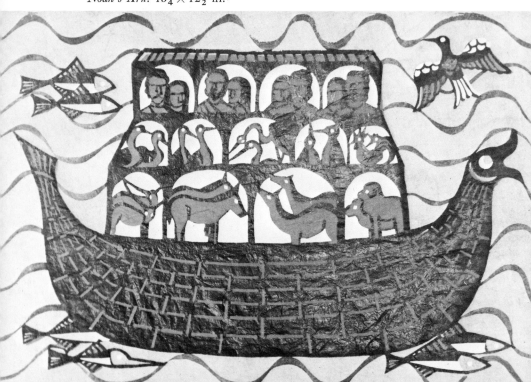

Masked Actors. $13\frac{1}{4} \times 17$ in.

Iwata, Kiyoshi

Born: 1940
Medium: woodblock

An original, skilled, patient, experimental young printmaker, Iwata is ambitious as well, turning out an extraordinary number of prints in a variety of sizes, papers, and modes of expression. His designs require precise printing of a dozen or more colors. Their intricacy demonstrates the artist's skill, and the painstaking details of a single block demonstrate his patience, since with a single slip of the knife all could be ruined. He is constantly trying out new materials and techniques.

Fluorescent inks are one area of Iwata's experimentation. Sometimes they are used sparingly, as in *Hanga 673-20*, where the color is limited to two tiny central circles; sometimes principally fluorescent inks are used, as in *Hanga 628-20*. (The numbers, by the way, are not intended as opus numbers; they are code indications for dates of issue.) Iwata is an artist whose development is well worth watching, considering his achievements during the relatively short span of his activity.

Ceremony. $18 \times 17\frac{1}{2}$ in.

Hanga 673-20. 36 × 29 in.

Hanga 628-20. 19 × 28 in.

Kabe, Hiroshi

Born: 1926
Medium: paper screen

The humor in these stencil prints lies in the artist's multipurpose use of shapes. The directions and colors change freely, but the basic contours remain the same, and the size is stubbornly identical throughout. His birds are great fun. Reduced to an absolutely minimal form without being unrecognizable, they are just beaks and eyes and tails, a curve representing the head and body, a point the feet, an identical shape the head and tail. A head with two points is a tufted owl, hooting at the moon. The play of forms creates abstractions that are at once simple and lifelike.

Kabe's paper-screen technique is not the traditional one used for kimono patterns and sometimes adapted for prints. A porous paper through which the ink can be forced is the secret of his unique method. The stencil is never cut but is printed and blocked out again and again until no porous section remains—a reduction process. The texture of the paper allows some of an undercolor to shine through if overprinted. When the work is complete the surface of the print is varnished in a clear acrylic, which adds brilliance. This method requires careful forethought as to design and color sequence.

Rival Melodies. 5½ × 6 in.

Road Home. 4 × 4½ in.

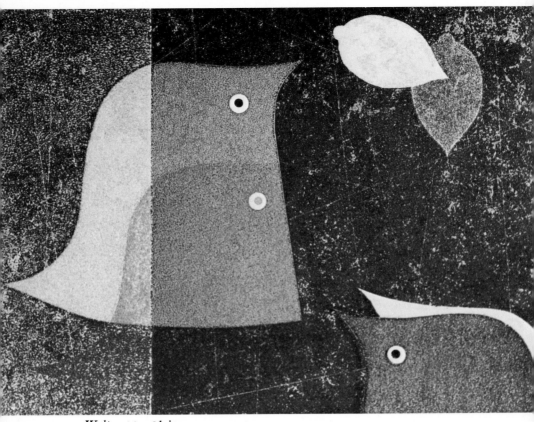

Waltz. $12 \times 8\frac{1}{2}$ in.

Out of the Nest. $9 \times 11\frac{1}{2}$ in. ▷

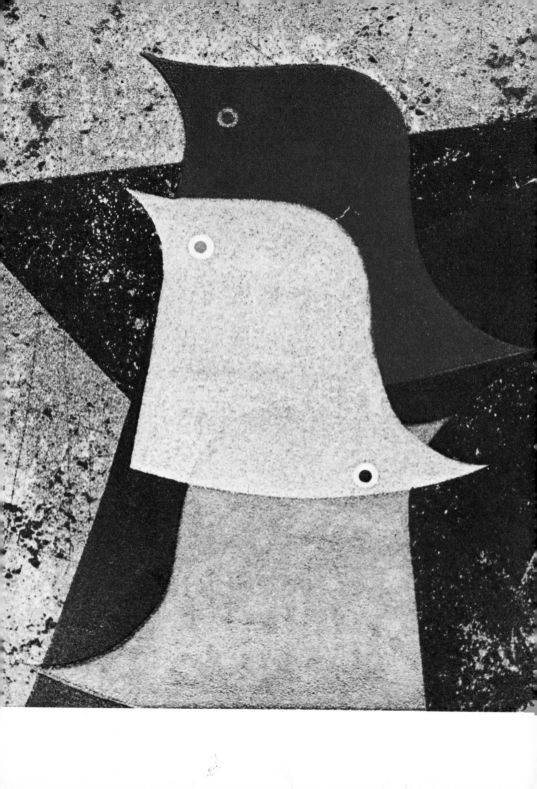

Kamiya, Shin

Born: 1942
Medium: silkscreen

Kamiya combines a photographic technique with the essential aspects of Oriental ink painting. His work seems at once immediate and permanent, combining the qualities of the inspired brush and the camera's eye. His skill resides in his use of photographic film. By fading or by covering portions of the negative while it is being exposed to light, he manages to give the image movement and direction in a manner both personal and sure.

The spiritual essence of splashed ink perfected by Sesshu, the fifteenth-century master painter, is captured in a medium that can be reproduced. It is probably this original approach that swayed the jury in a recent World Print Competition of the California College of Arts and Crafts to pick this artist's work for a Special Edition Purchase Award from among some seven thousand entries.

Blackout. 19 × 29 in.

Outflow. 18½ × 28½ in. ▷

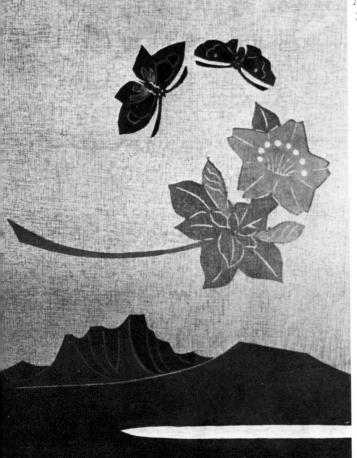

Kanamori, Yoshio

Born: 1922
Medium: woodblock

Fantasy and realistic depiction are effortlessly combined in these landscapes that recall the misty atmosphere of the Japanese archipelago. Gray lakes, peaked mountains, and lavender dusk skies are but the ground on which fantastic visions play. Butterflies no meadowlark has come upon arc across a twilight sky while a spray of graceful, surreal flowers floats mysteriously into view.

The imagery is more relaxing than threatening; the colors are calm and modulated. This is a dream world, but one touched upon in restful sleep rather than frustrated wakefulness. These poetic woodblocks are timeless in style; they fit in the category neither of ukiyo-e landscapes nor of the imaginative future world of the moderns. But no matter what the period, their source is clear: they are unquestionably Japanese.

Mountain Lake—N44. 12 × 15½ in.

Imaginary Bird. 18½ × 24 ▷ in.

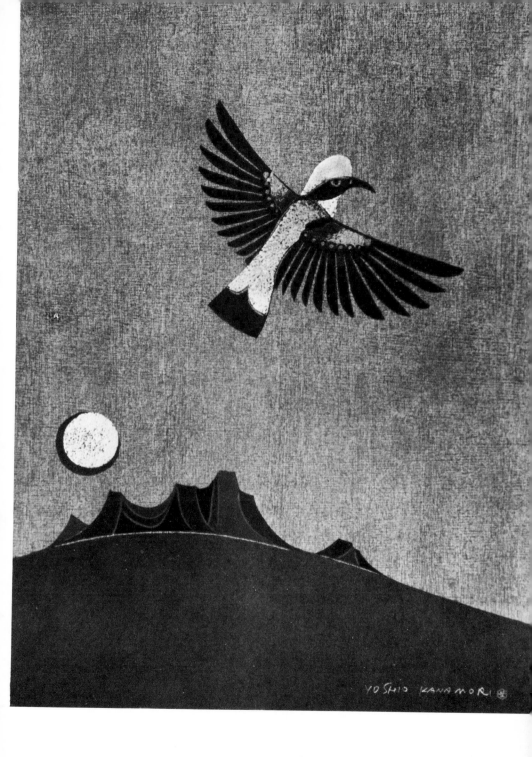

Karhu, Clifton

Born: 1927
Medium: woodblock

Karhu's art is closely related to the ukiyo-e prints of the past. His themes are inspired by places that existed then, and like the ukiyo-e artists he spares no pains in preparing the number of blocks required to achieve the results he visualizes. However, Karhu has adopted certain innovations that for today's viewers are an improvement over the traditional prints. He has increased the size of his prints, exposing finely drawn detail, and has intensified his color sequence, the latter falling into key and enriched by overprinting an intricate line block. He has a talent for creating mood in such touches as a shaft of sunlight filtering into a courtyard or illumination falling onto a street at dusk.

Phonetically "Karhu" could be a Japanese name, but it belongs to an American originally from Minnesota. Like the sound of his name, his art is Japanese in so many ways that he deserves to be included in a report on Japanese graphics. Karhu not only designs his prints but has mastered the meticulous cutting and printing process, which the ukiyo-e masters left to their assistants.

Snow at Katsura. 24¾ × 15⅜ in.

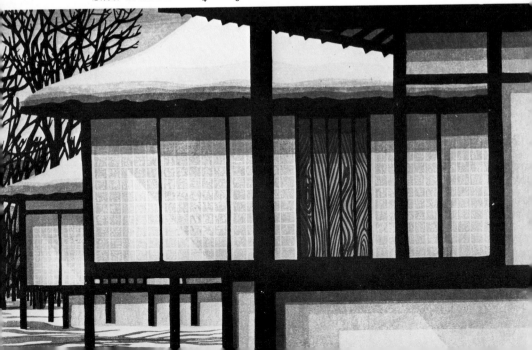

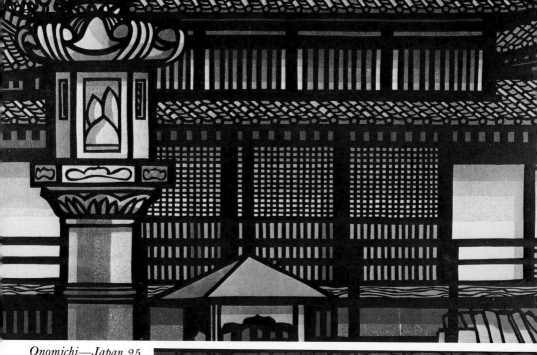

Onomichi—Japan. 25 × 15½ in.

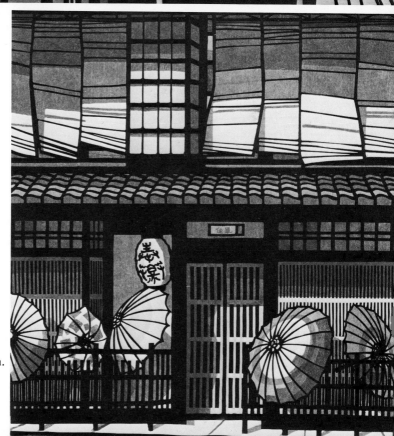

Gion II. 23 × 26⅜ in.

Kawada, Kan

Born: 1927
Medium: stencil

These stencil prints combine the intricacy of latticed-window houses with the reassuring simplicity of open paths and stone walkways. It is the kind of selective seeing that neither the camera nor the ordinary eye possesses, recording the surviving sights of ancient Japan that both her people and foreign visitors love so much: castles, traditional warehouses, wood-beamed country houses, old-style shops.

The colors are all natural dyes: stone blues, umbers, grayish blacks, sometimes a surprising red or mustard sky. In the stencil technique used for these prints a master stencil provides the structural elements, which are dark. Other stencils are used for the accents and colors.

Among the many stencil artists in Japan today, and among the many print artists specializing in traditional architecture, Kawada stands out for his satisfying results, based on a patient hand and an eye for both detail and abstract design qualities.

Kurashiki 3. 17 × 23 in. ▷

Kyoto House. 16½ × 11 in.

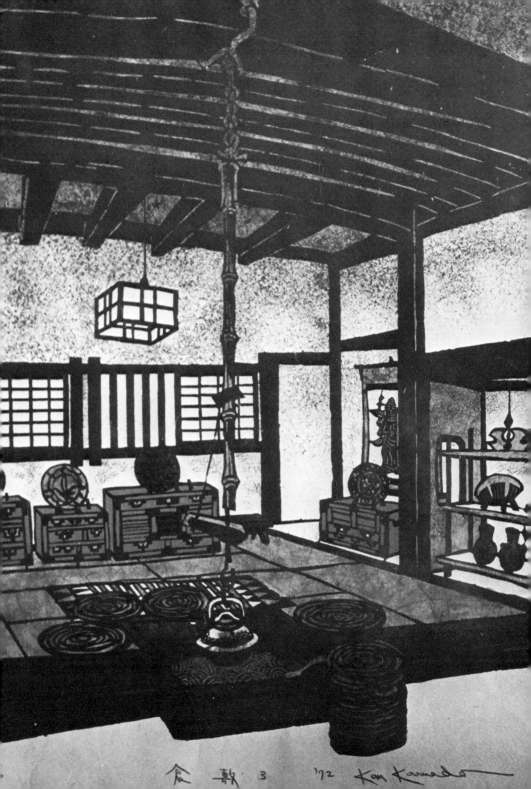

食敷 3 '72 Ken Kawada

Kawahara, Hideo

Born: 1911
Medium: woodblock

In these prints, the subject matter is constant but the technique changes constantly—quite the opposite of the procedure followed by most print artists, who perfect a mode of expression and then search for themes. Every Kawahara print has a seagull in it; sometimes the gulls are treated realistically, sometimes in hard-edged abstraction. The prints vary in emotionality as well as elegance. In fact, they demonstrate the essential role method plays in print art, for it is really quite difficult to see any relationship among some of these works except for the presence of a rather odd bird in all of them.

The hard-edged prints suggest graceful flight through rhythmic swirls of color. Here the birds are almost accidental, hardly necessary except as a sort of trademark. In the more realistic prints, which are highly dramatic and active, the wings stretched high in the air convey a sense of power and even violence. In this group the birds are flying; in the hard-edged group they are at rest. Each line of each print reflects this difference.

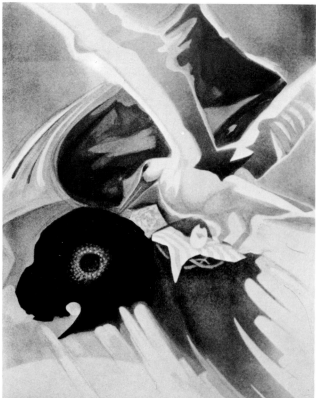

Black Flower.
$14\frac{1}{2} \times 20$ in.

Alone (Red). 15 ▷
$\times 20\frac{1}{2}$ in.

Kida, Yasuhiko

Born: 1944
Medium: woodblock

In one respect there is a kinship between the great Hokusai, who lived more than two centuries ago, and the prolific young man named Yasuhiko Kida. Though dissimilar in style and draftsmanship, their works show people as they are, with humor and sometimes a little vulgarity.

Kida illustrates the night life of the denizens of Tokyo's Shinjuku and Ikebukuro districts, and other late-evening haunts of his contemporaries in pursuit of pleasure. He also records the fun of folk festivals all over Japan. It is rare today to find a young artist interested in folk traditions who has the skill to capture their gaiety and sparkle.

Utilizing a strong sense of design, Kida's black-and-white woodcuts have none of the refinement of Hokusai's drawing, but let us hope Kida doesn't change: some of his scintillating charm might be sacrificed.

Untitled. $6 \times 8\frac{1}{2}$ in.

Every Day Is a Happy Day. ▷
7×10 in.

Last Train. $26 \times 4\frac{3}{4}$ in.

Kimura, Kosuke

Born: 1936
Medium: photo intaglio

Kimura has won the praise of Japan's leading art critics for his intelligence and skill in using photo-intaglio techniques. He generally includes several dozen photographic images in a single print, composing them onto three or four sheets, each printed in a different color. Objects of the same color relate logically, a quality lost in a black-and-white reproduction. By joining the various sheets with their scattered images into a single print, the objects overlap to the extent of creating a unified work without resulting in a confusion of forms. Another of this artist's techniques is to use a printed acetate sheet as an overlay, futher blending the images.

Kimura's *Relation 73-2* won him a Special Edition Purchase Award in the World Print Competition of the California College of Arts and Crafts in October 1973. Another Kimura print in the same show won a merit award.

Present Situation. $22\frac{1}{2} \times 15$ in.

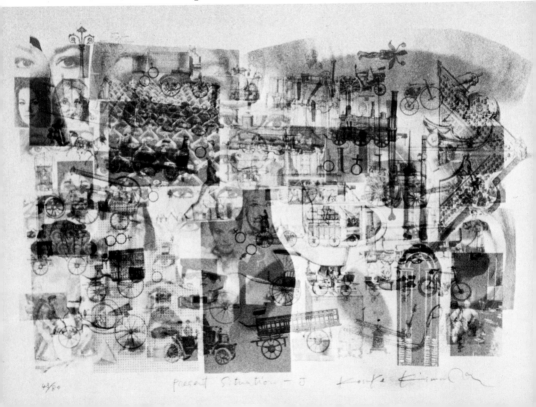

Present Situation—*26.* *22 ×*
16 in.

Out of Time—*26.* *20¾ × 29½*
in.

Kimura, Risaburo

Born: 1924
Medium: silkscreen

Kimura, who lives in New York City, has used print art to make a bitter social comment on the modern environment. Toppling high-rise buildings in cubist patterns predict the decay of the city; ominous clouds, crosshatched with confusing streaks, hanging over airports emphasize congestion. Aerial views reduce cities to a jumble of minute patterns united artistically by swirls of expressway cloverleafs and by sharply defined transportation networks. A weak sun in a smog-blue sky exposes a foreground of rubble patterns.

As compelling as the poignant satire of his prints may be, it is Kimura's use of appropriate color schemes and his sound composition that enable his works to stand firmly on their own artistic merit.

City 124. 23 × 16½ in.

History of a City 1999.
35×46 in.

History of a City 1998.
35×46 in.

Kinoshita, Tomio

Born: 1923
Medium: wood engraving

These wood engravings follow the technique of early European print artists, though they could never be mistaken for fifteenth-century graphics because of their simplified style, the artist's characteristic mark. What Kinoshita has borrowed from Cranach and Dürer is their methods of varying the width of lines in order to create depth and dimension. But whereas the Europeans were aiming at realism, these large prints are directed toward creating emotional response. One of Kinoshita's favorite subjects is a grouping of people that at first appears to be one person in a variety of poses but on examination reveals differences that suggest characteristic facial expressions. The variations in expression are entirely the result of different line spacings rather than of overall form.

Here is the generic human animal, devoid of racial and usually of sexual identification but possessing one crucial quality: individuality.

Faces (In Projection). $12\frac{3}{4} \times 17$ in. ▷

Face. $35 \times 24\frac{1}{2}$ in.

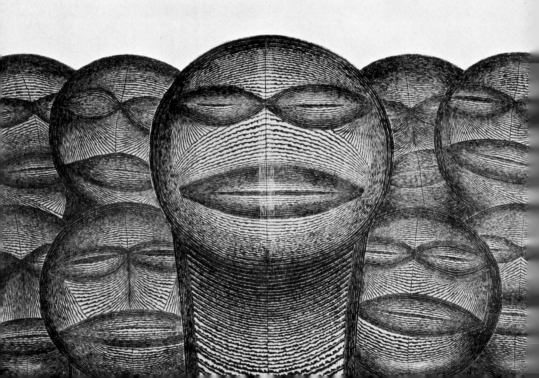

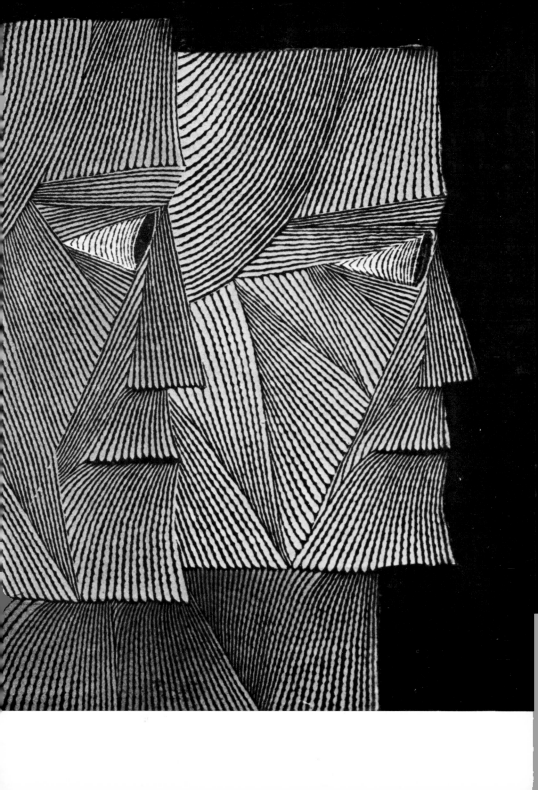

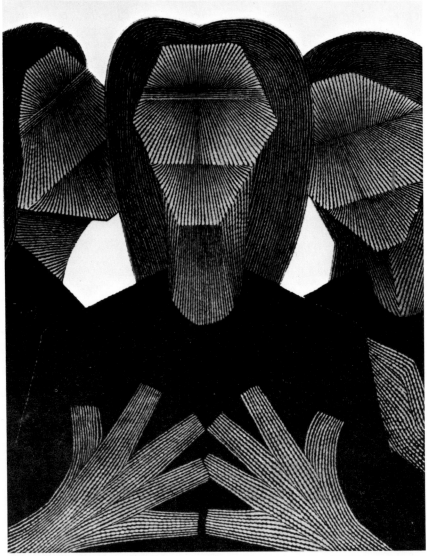

Faces Tomorrow. $14\frac{3}{4} \times 22\frac{1}{4}$ in.

Kitaoka, Fumio

Born: 1918
Media: wood engraving, woodblock

A mature artist who has been exposed to both Eastern and Western influences, Kitaoka has abandoned the wood-engraving technique and literal approach he used abroad and reverted to the Japanese woodblock. Emphasizing surface and color at the expense of line, he has used the color block to full advantage in his fine nonobjective themes, as well as in his creative Japanese subjects.

He exposes his imaginative sense of pattern in one print showing great lengths of newly dyed silk being washed in a river and in another presenting the complex design of poles bracing the sprawling limbs of a carefully tended old pine. Kitaoka's colors are grayed, but intense bits sparkle here and there, making the most of an artist's license to emphasize nature's truths.

Mountain Lake. $21\frac{3}{4} \times 15\frac{1}{2}$ in.

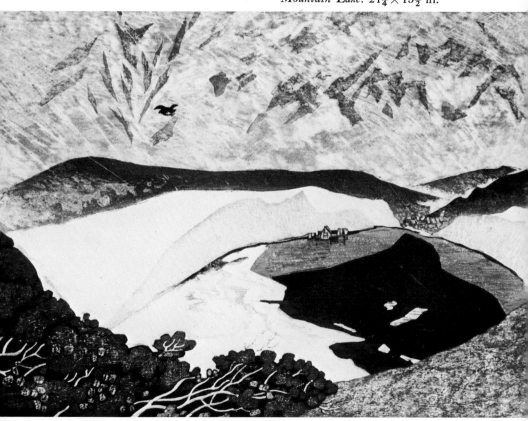

Washing Silk. $15\frac{1}{2} \times 21\frac{1}{2}$ in.

Pine Tree. $21\frac{3}{4} \times 15\frac{1}{2}$ in.

Koike, Nobuko

Born: 1939
Medium: etching

Landscapes of hillside villages, pastoral vistas, and narrow street scenes are the favorite subjects of Nobuko Koike. She intricately inscribes her etchings with a lyrical sensibility, exploiting each detail for its decorative qualities. She fills each print to its very brim with an interplay of fanciful patterns interspersed with pretty girls, animals, and birds, creating a happy, carefree world.

Working with equal facility in either black and white or mixed colored lines, her inspiration is derived sometimes from scenes in France, where she now lives, and sometimes from scenes in Japan when she visits the land of her birth.

Song of a Goat. $14\frac{1}{4} \times 12$ in.

86

Shop of Ohotsuku.
$8\frac{1}{2} \times 10\frac{3}{4}$ in.

View of a Small Town. $9\frac{3}{4} \times 6\frac{1}{4}$ in.

Kono, Yoshio

Born: 1921
Medium: silkscreen

Yoshio Kono instills a breathtaking beauty into simple geometric shapes through his methods of shading in a medium that is usually flat. He uses the silkscreen to grade his forms evenly so that they assume a startling new dimension, extending in front of and receding in back of the plane of the paper. The rhythm of a repeated shape is emphasized by this gentle change of values.

Kono relies on the interplay of circles to discover new spatial relationships that could not physically be engineered, yet are too precise to be romantic or visionary. He inserts an occasional straight line into these basically circular compositions to sharpen contrasts and anchor his designs.

Kono's color is as stable as his draftsmanship. Avoiding poetic tones to maintain an overall consistency, he has a talent for combining colors that are seldom seen together.

Face in Circle—4. $15\frac{1}{2} \times 21\frac{1}{4}$ in.

Face in Circle—1. $15\frac{1}{2} \times 21\frac{1}{4}$ in.

Kosaka, Ryuji

Dates: 1912–72
Medium: woodblock

Kosaka will long be remembered for an ambitious number of prints falling into two groups. In his *Blue Stone* series, the backgrounds of ripples, reeds, or gently falling rain are printed in watercolor on damp paper. Flat curved-edge shapes representing stones are then impressed in thick poster paint on the completed but still damp background, which results in an evenly textured surface. The rich dark blue of the stones varies from print to print, leaning toward green in some and toward purple in others, elegantly complementing the matte quality of the print.

Kosaka's *Red Stone* series involves forms peculiar to Japan, forms adopted from the ancient comma-shaped jewel-stones used as primitive ornaments. In any one print, the same shape is repeated to create an overall formalized pattern. Although this series is rendered in an exquisite palette of red tones, occasionally a single stone is printed in jade green, providing an exciting focal point.

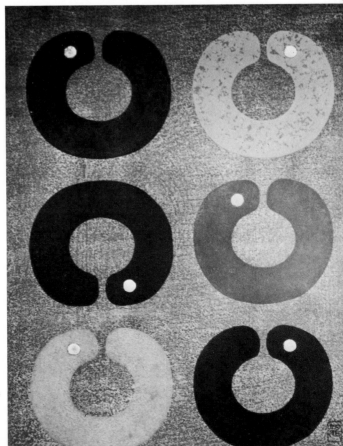

Six Rings # 17. 17½ × 23 in.

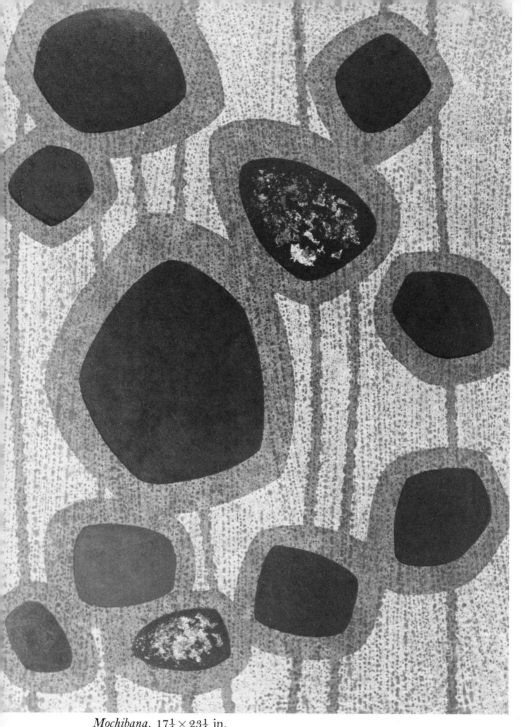

Mochibana. $17\frac{1}{4} \times 23\frac{1}{4}$ in.

Kubo, Akira

Born: 1926
Medium: silkscreen

Kubo concentrates mainly on simple geometric forms, especially the rectangle and the square. Concentrically decreasing the size of the chosen form, he alters its width with each step. At times he positions the shape off center or turns a square diagonally.

The magic of a Kubo silkscreen is evoked through his choice of color, for which he has no consistent formula except good taste. He may change color and not value, or show a dramatic contrast in color. He may use one color and change tones. He treats the diminishing bands flatly and introduces a new element only in the eye of the design.

Kubo has abstracted the mesmeric quality of an ancient object, the prayer rug, and presented it in modern terms.

Composition # 52. 18 × 18 in.

Composition # 24. $18 \times 19\frac{1}{2}$ in.

Composition # 37. Detail. $12\frac{1}{2} \times 16$ in.

Kunishima, Seiji

Born: 1937
Medium: silkscreen

Kunishima's art is an example of the effect industrial expansion is having on the nature-loving Japanese. He limits his artistic vocabulary to the kind of environment that today envelops the urban resident. By using the checked pattern of the traditional Japanese paper-covered door as a background for all his prints, he gives further emphasis to the feeling of being enclosed.

Kunishima skillfully reassembles sections of heterogeneous photographs of mechanical objects in a new arrangement with sweeps of color. Some of his prints have the dimension of a piece of sculpture and some are flat in design, but all carry a convincing impact.

Window. $23\frac{3}{4} \times 25\frac{1}{4}$ in.

Window 72-8. 20 ×
31 in.

Window 72-1.
20 × 13 in.

Kurozaki, Akira

Born: 1937
Medium: woodblock

These prints remind one of a theater stage before the opening of a play, with staircases leading nowhere at all, boxes of assorted sizes, some bathed in spotlights, cushions, balls, and assorted props. Even the vertical strips of color that lead the eye into the scene resemble stage wings and backdrops. Kurozaki's repeated use of royal reds and purples is as much a hallmark as his compositional style. These deep pigments when applied to absorbent Japanese paper resemble velvets and further augment the theatrical impression. Is Kurozaki saying something about the stage of life? At any rate, one series is called *Allegory*.

This artist is extremely active in the print world both in Japan and abroad. He is a frequent recipient of awards in international shows, and this no doubt is one factor of his popularity.

Allegory No. 84. $17\frac{3}{4} \times 12$ in.

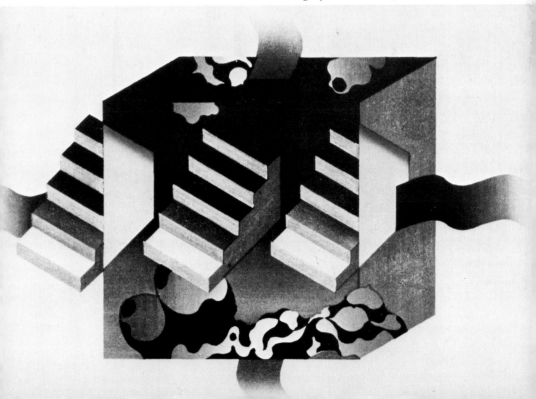

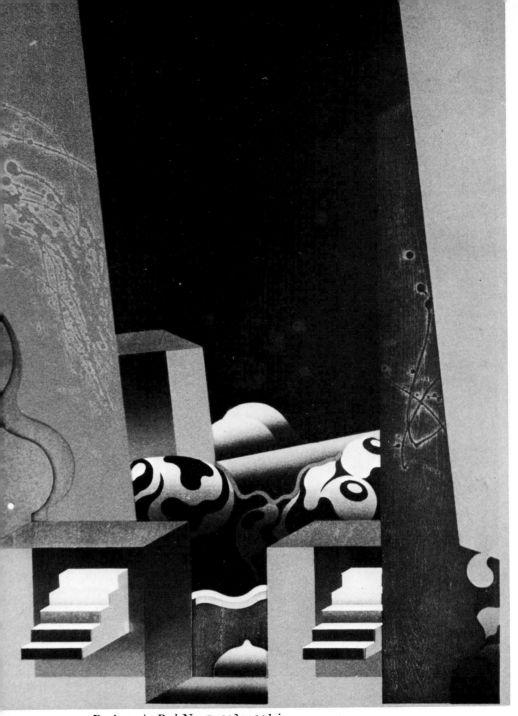

Darkness in Red No. 6. $21\frac{3}{4} \times 31\frac{1}{2}$ in.

Kusaka, Kenji

Born: 1936
Medium: woodblock

The pure, vivid colors in these prints create an exciting tension. In *Work 73-9*, for example, the ground color is a deep and vibrant red. Against this two yellows, a reddish orange, cerise, cobalt, navy blue, and green have been printed—all brilliant hues. This daring combination is successful first because the powerful contrast of lines and curves absorbs some of the force of the clashing hues, and second because the apportionment of the color areas permits the ground color to unify the whole. The result is a fresh and startling print.

Ever since 1966, when he came to prominence by winning the National Museum of Modern Art Award at the Tokyo international biennial, Kusaka has been known for his diagonally racing streaks of color. His development has been speedy and sure, moving first to an architectural style that gave his works depth and air, and then to the more recent egg shapes that interrupt angularity without suppressing it. In these latest works, the diagonal lines act as horizons in an abstract landscape made surreal by the addition of bubbly clouds. His bold innovations are certain to lead him further.

Work 73-9. $15\frac{1}{2} \times 21\frac{1}{4}$ in.

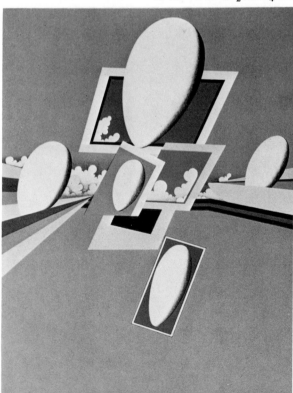

The Feel of Autumn. 15 × 21 in.

Maki, Haku

Born: 1924
Media: mixed

Two unique qualities of a Maki print are the textures achieved by working the designs in wet cement and the use of Chinese characters as design motifs. Sometimes he exaggerates an element of a word to give it a whimsical touch, then again without concern for legibility he refashions a character for beauty and composition alone. The cement on which the designs are inscribed can be worked deeply and precisely, creating prints that look very different from those embossed through other processes.

Maki studied at the Modern Print Research Society, where he was influenced by Koshiro Onchi. Today, perhaps as a gesture of respect to the master, Maki often uses a circular form enclosing a burst of lines, and a system of labeling some of his works poems, as Onchi did.

Maki richly deserves his international reputation, which was enhanced by his illustrations for *Festive Wine*, a book of ancient Japanese poems published in 1969 by John Weatherhill, Inc.

Poem 70-47. $7\frac{1}{4} \times 10\frac{1}{2}$ in.

Poem 70-60. $4\frac{3}{4} \times 6\frac{3}{4}$ in.

Cell. 14×14 in.

Matsubara, Naoko

Born: 1937
Medium: woodcut

Calligraphy and strong brushwork have long been admired in Japan. The essence of this art could not have escaped the eyes of the daughter of a Shinto priest who lived her first twenty-three years in Japan. This shows clearly in Matsubara's ability to produce graphics in powerful black and white through the medium of the woodcut. Although her subject matter is frequently derived from her extensive foreign travels and her adopted American surroundings, she reveals an unmistakable reliance on her Japanese heritage. She injects strength into her art by seeing things structurally, be they animate or inanimate, and by emphasizing and simplifying for the sake of design.

She has exhibited in many cities in Europe and America, and her work can be found in numerous museums, as well as in private collections. Shiko Munakata has complimented Matsubara's versatility and power and has said she is the first Japanese woman artist to display such qualities.

War God. 18 × 14 in.

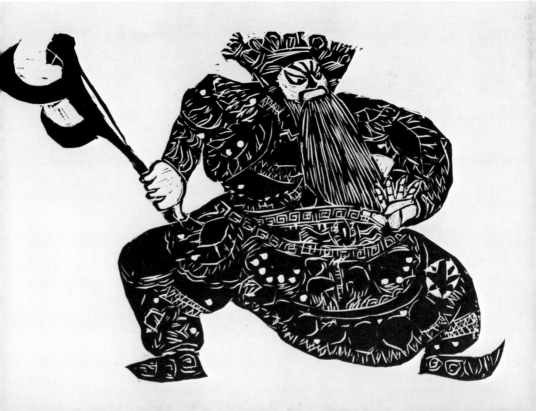

Plum Tree. 14 × 14 in.

Sylvan Snow. 24 × 12½ in.

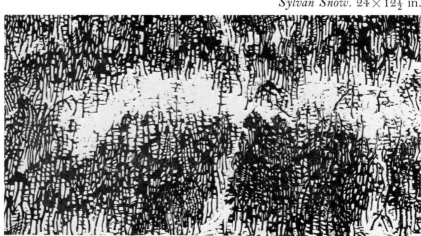

Matsubara, Tatsuo

Born: 1941
Medium: silkscreen

A lunchtime setting seems an unlikely print theme for a young artist to adopt again and again; however, Matsubara transforms this commonplace subject into a magically vibrant series of prints.

Matsubara is a colorist, who has studied his subject for contrasts: outdoors versus indoors, sunlight versus shadow. He interprets these differences in terms of colors that are warm or cool: red-oranges and yellows as opposed to gray-blues, greens, and purples. This complementary selection of rich tones suggests a Gauguin tropical scene except that in Gauguin's time fluorescent inks were unknown. It is through the generous use of these dazzling colors that Matsubara gives his silkscreens a very contemporary look in spite of their subject.

Lunch Time 7. $22\frac{1}{2} \times 16\frac{1}{4}$ in.

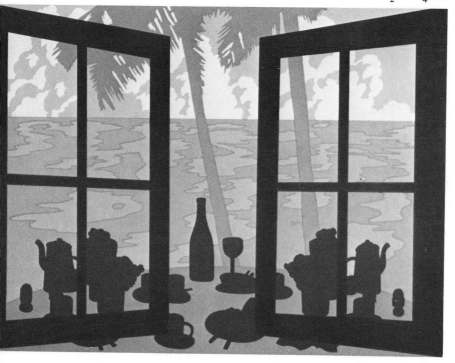

Lunch Time 2. $24 \times 17\frac{1}{2}$ in.

Lunch Time 6. $22\frac{1}{2} \times 16\frac{1}{2}$ in.

Matsumoto, Akira

Born: 1936
Media: woodblock, intaglio, silkscreen

Skilled in a variety of artistic media, Matsumoto has undergone a remarkable growth and development over the past decade or more. Beginning as an abstract woodblock artist, he soon incorporated recognizable imagery into his works, and he was one of the first Japanese print artists to use embossing. When human figures became popular in prints, Matsumoto took up the fashion, but with a difference: the figures' clothing was emphasized, while the rest of the subject was printed in a barely visible ink. Most recently he is using silkscreened photographic images.

A creator who constantly changes his means of expression is not necessarily appreciated, but Matsumoto is special; he has been amazingly successful in everything he has done, winning a great many awards and maintaining the highest professional standards. It may be said that he has spent this decade searching for himself and searching for his mode of expression, but it has not been an unfruitful adventure, and his future work is awaited with the expectation of being pleased as well as surprised.

Print 13. 24 × 22¾ in.

白い手袋の花 A. Matsumoto 1956

Mode 3. $22\frac{3}{4} \times 25$ in.

Print # 2. $22\frac{1}{2} \times 24\frac{1}{2}$ in.

◁ *White-faced Child.* $18\frac{1}{2} \times 24\frac{3}{4}$ in.

Matsutani, Takesada

Born: 1937
Media: silkscreen, intaglio

Matsutani has become known for his fused, flat pastel backgrounds and blazingly vibrant, almost magnetic centers. Of late, however, he has switched to a photo-intaglio process that results in a remarkable three-dimensional effect. As in his earlier work, everything is concentrated on a central abstraction; what is different is his means of evoking surprise. Both types of works are skillfully executed, the one revealing a remarkable color grasp, the other an equally remarkable sense of explosive surface.

The new, less colorful works won Matsutani an award in the World Print Competition of the California College of Arts and Crafts in October 1973. The prize, a Special Edition Purchase Award, was for his *Object 6*. Perhaps we should have been able to foresee this drastic change, but it was as surprising as the work itself. What Matsutani will come up with next is anybody's guess, but it is certain to be interesting.

Lamp Pink. 20 × 26 in.

Object 6. $20\frac{1}{2} \times 26\frac{1}{2}$ in.

Propagation 73. 20×28 in.

Minomura, Yoshio

Born: 1942
Medium: etching

Minomura's perceptive statements on present-day social pressures are unveiled in a series of thought-provoking graphics. His symbols include everything from the commonplace, such as combs, kettles, beautiful women, and rocking chairs, to the universally meaningful, such as bombed buildings, spilled blood, scales, pens, and cameras; and he records the criminal elements with the pistol and the addict's needle. He ties all his symbols together with a suggestion of time, a mark always found in this artist's work, whatever the medium.

Minomura renders his caustic comments in fragmented sketches physically intensified by an original matting technique. Each element is seen through an irregularly edged peephole torn in the mat paper itself. Because of the scattered composition of the sketches, each print has the striking effect of a bullet-ridden wall.

Diary 202. $15\frac{3}{4} \times 22\frac{1}{2}$ in. ▷

Diary 211. $22\frac{1}{2} \times 15\frac{3}{4}$ in.

Mishio, Fuki

Born: 1931
Medium: silkscreen

In these hard-edged prints, fantasy is projected with clarity and directness rather than the soft focus once associated with psychological themes. Now, perhaps because of the influence of films, direct statement has become an appropriate means of describing dreams, and the silkscreen medium has become an ideal way of expressing them.

These works require great patience in their execution. The artist spares neither time nor effort, often using as many as fourteen separate colors, as in *The Swing*, to achieve the desired results. The path and the floating box shape are printed in a faint off-white to distinguish them from the upper ground white. The foreground is yellowish brown, while the swing's wavy ropes are done in a fluorescent cerise.

Blue Waking. $17\frac{3}{4} \times 17\frac{3}{4}$ in.

Swing. $13\frac{1}{4} \times 17\frac{1}{4}$ in. ▷

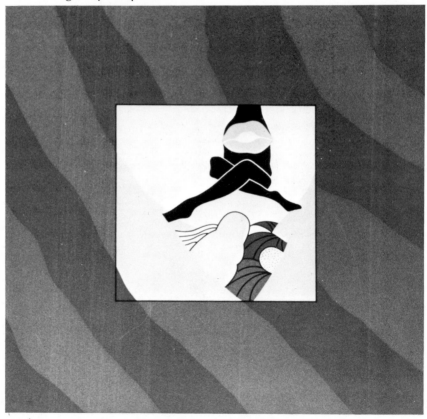

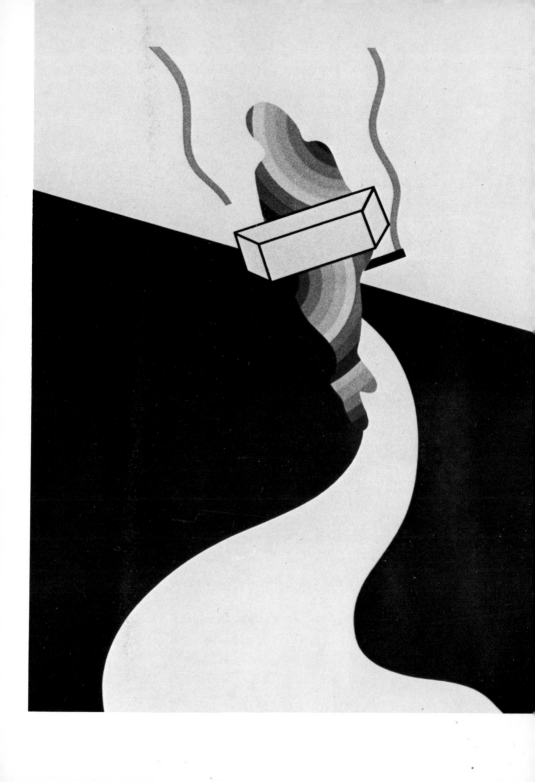

Miyashita, Tokio

Born: 1930
Media: woodblock,
intaglio

In these prints, irregularly shaped metal plates are impressed onto dampened handmade paper to produce finely detailed inset images. In Miyashita's recent prints, such as *Prism*, the intaglio portions are larger, backed by matte colors in broad horizontal stripes. Nevertheless, Miyashita remains first and foremost a colorist, as a result of his training under Jun'ichiro Sekino. This influence is seen mostly in his brilliant, flat grounds, printed by woodblock techniques.

The etched fragments have a seemingly random shape and relationship to the whole, but on inspection the positions and shapes of the impressions, as well as the objects contained within them, are related logically and formally. The asymmetrical balance is as planned as the studied placement of stones in a Japanese garden.

Mail from the Sea. $13\frac{1}{4} \times 22\frac{3}{4}$ in. ▷

Prism. $23\frac{3}{4} \times 17\frac{1}{2}$ in.

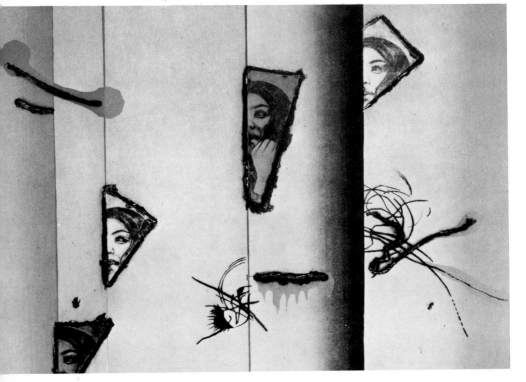

Mizufune, Rokushu

Born: 1912
Medium: woodblock

Mizufune is a sculptor who has become famous for his print work as well. The prints are characterized by color contrast and a concentration on edges. By deliberately mismatching the blocks, he produces jagged edges and dark, meandering lines that serve to unify the works and capture attention with forms that sometimes look carelessly torn or cut.

The strongly contrasting colors identify the artist, as do the figures distorted for purposes of design. Bright colors are nearly always located in a single area. One of his innovations is the use of black paper for printing. Thus some of the darkest, most emphatic lines are really not printed at all. Mizufune's works retain a tentativeness that is not what one would expect from a sculptor, but this may be one reason that he makes prints—for the informal fun of it. In any event, he is quite at home as a print artist.

Dawn. 10 × 13⅜ in. ▷

Lamp Lamp. 21¼ × 18 in.

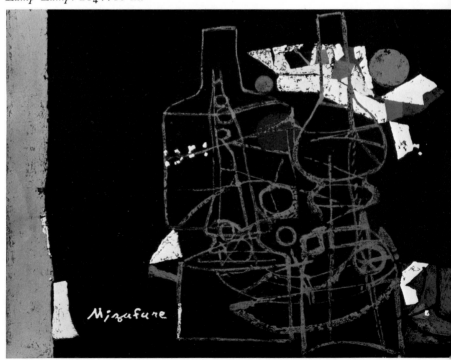

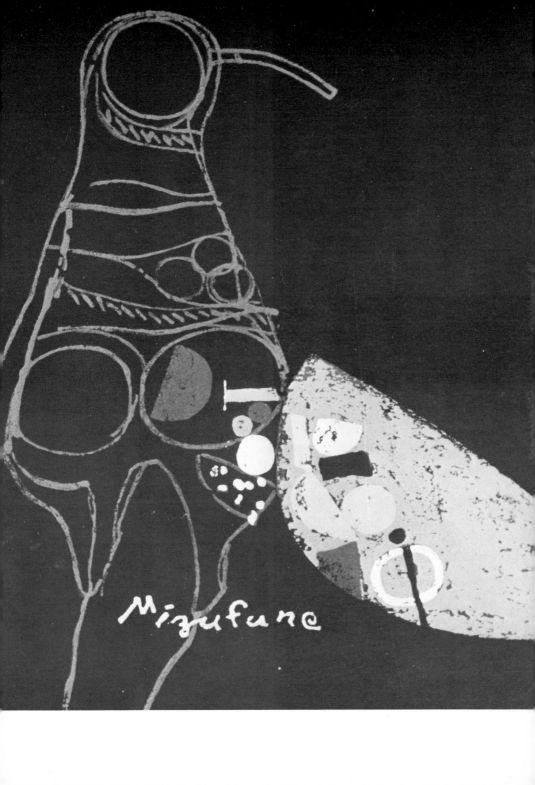

Mizufune

Mori, Yoshitoshi

Born: 1898
Medium: Japanese stencil

The stiff brocade costumes of Kabuki characters striking a climactic pose, the entangled bodies of tipsy merrymakers carrying a heavy portable shrine, a devil-like guardian of a temple gate, busy native craftsmen, and action-filled scenes of Japanese folklore make up the meaty range of subjects of a Mori print. No matter what the subject, the images are united in a dynamic mass that has become Mori's identifying mark.

Mori is a folk-artist—in his expression, his stencil technique, his simple natural materials. Perhaps his only concession to modernism is the outsized dimensions of many of his stencils. The colors are earthy, natural pigments in keeping with native off-white papers. They unify the designs rather than counterpoint the bold lines, and implement the strength of his style. Mori's prints are a record of his generation; they document an age that has all but disappeared. Hopefully these robust scenes will convey the vitality and joy of that period to coming generations.

Fox Mask Kagura. 25½ × 30½ in. ▷

Hikikomi Roppo. 30 × 26 in.

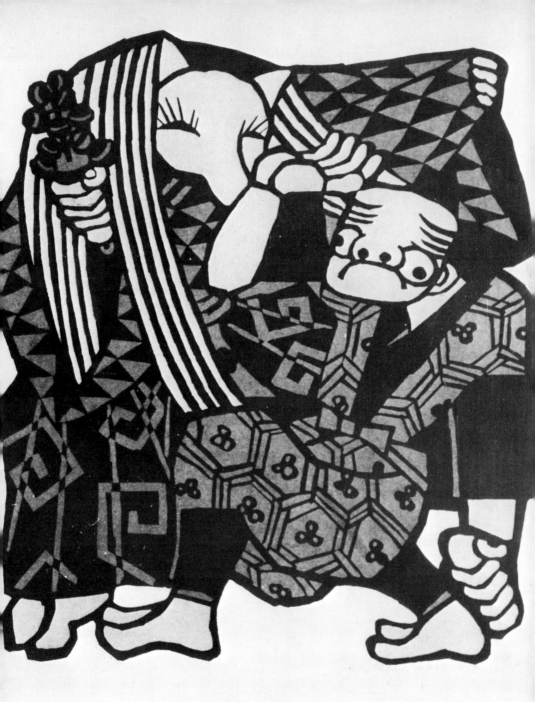

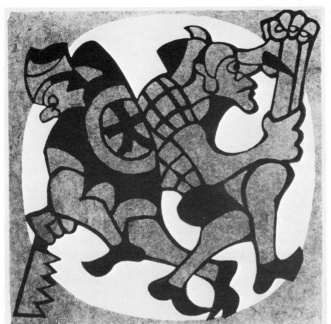

Carpenters in a Circle. $10\frac{1}{2} \times 11$ in.

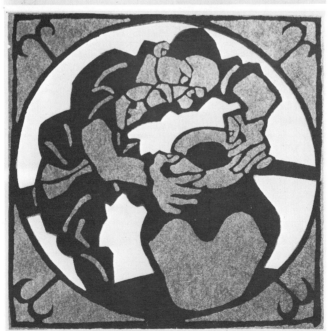

Potter. $10\frac{1}{2} \times 11$ in.

Morishima, Isamu

Born: 1935
Medium: lithograph

The sea is never far away for artists who reside in the Japanese islands. Subjects from this source have been utilized in folk art and decorative design for centuries but only incidentally by graphic artists today. Morishima is an exception. He explores the beaches, the sand, the tidal flats, and through the medium of lithography records the things he finds washed ashore.

The beaches of Japan are treasure-troves of unexpected shapes, since the "black current," or Kuroshio, that flows swiftly along the Pacific coast is laden with fish and crustaceans from the South Seas, periodically deposited on shore during high tide. Ambling along the tidal flats, one can nearly always find marine life gasping for breath or clinging desperately to rocky surfaces. Some of Morishima's lithographs are still-life studies, but others record struggles, with movement captured through sketch lines and highlights.

The colors are limited so as to create images that are not literal. Sometimes an entire print bears a mustard or grayish blue tint. Such simple coloring tends to subdue the intricacy of the drawing and enhance an undersea mood.

Fish. $23 \times 17\frac{1}{2}$ in.

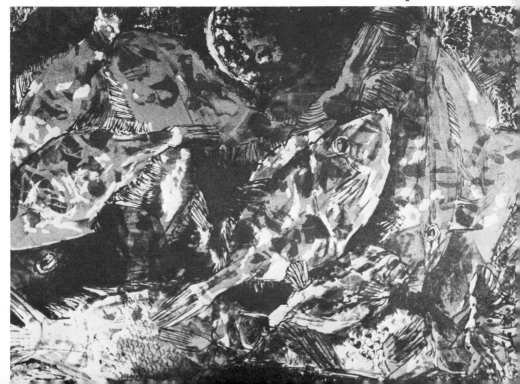

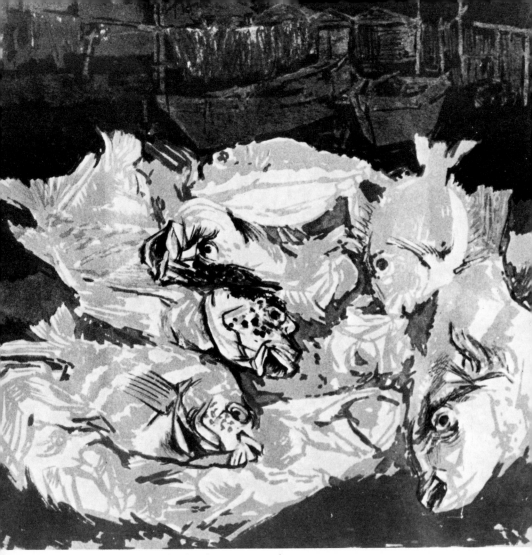

Fish Piled on the Seashore. 19 × 19 in.

Morozumi, Osamu

Born: 1949
Medium: woodblock

This relative newcomer to the woodblock medium has already made a place for himself through his original approach. The spheres and arabesques of his prints have a convincing depth and flow that many woodblock prints lack. The unique highlighting and clever architecture force the eye to move back and forth, following the deepening thrust of the pattern. The effect is even more amazing in the full-size prints than in the necessarily reduced reproductions shown here. The unique shapes stimulate an urge to explore, to climb through the arches and over the mounds, if only to see the mysterious play of light from other angles.

Executed with remarkable skill, the stipple technique is rarely if ever used in woodblock prints, at least in Japan. The result is a sculptural mass free of the usual outlines. Printed from a single block, the impressions are superbly effective in black and white.

No. 18. $34\frac{5}{8} \times 19\frac{1}{4}$ in.

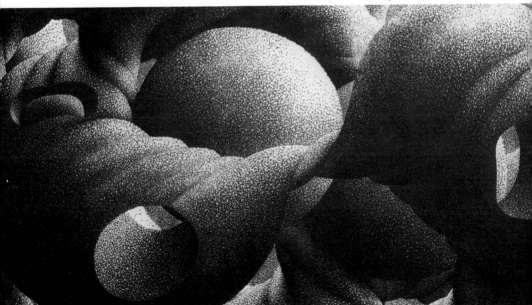

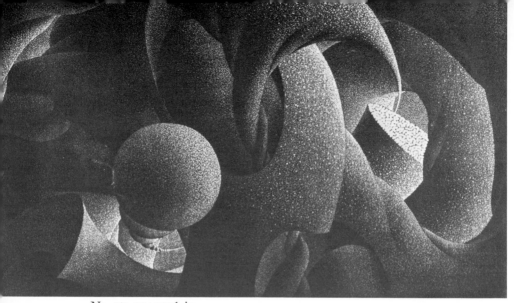

No. 17. $33 \times 20\frac{1}{2}$ in.

No. 16. $21\frac{1}{2} \times 18$ in.

Munakata, Shiko

Born: 1903
Medium: woodcut

Internationally recognized as a master of the woodcut, Munakata is admired for his loyalty to his heritage, to his religion, to his inner self. The strength and rhythm of his dynamic black-and-white impressions bridges cultural borders. Oblivious to outside influence, Munakata attacks his wood with a fiercely passionate zeal. The powerful unifying strokes and spontaneity of design are testimony of this almost spiritual relationship between the artist and his wood.

Munakata's early associates were a *mingei* (folk-art) group, all of whose members were dedicated to the same basic philosophy of maintaining honesty of expression although working in different media. Perhaps this mutual admiration and encouragement gave them more strength than if they had been in competitive fields.

Munakata was designated in November 1970 as a recipient of the Order of Culture, Japan's unique and admirable method of recognizing her creative individuals. Munakata is the only print artist so honored to date. Even without this distinguished honor, Munakata would have remained an outstanding artist of the century.

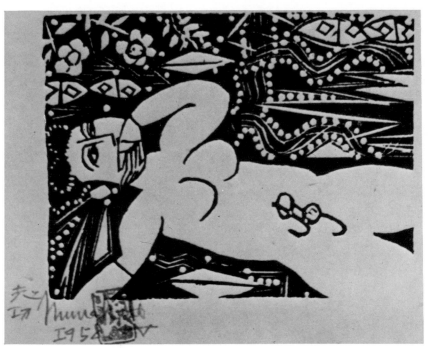

Untitled. 11 × 6½ in.

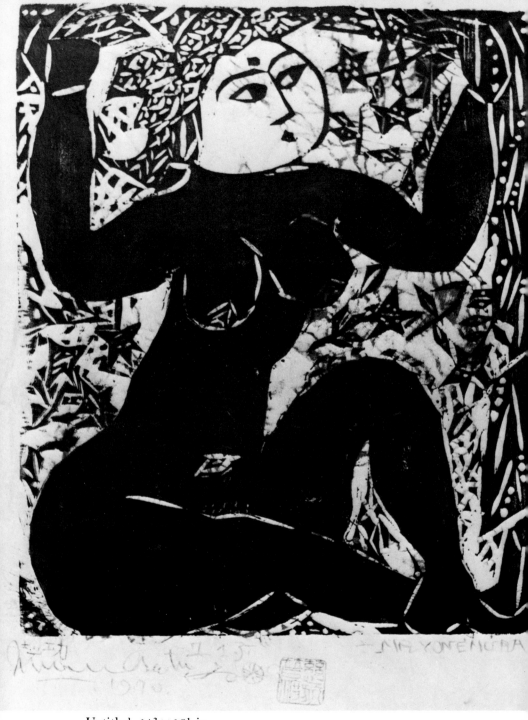

Untitled. $14\frac{3}{4} \times 16\frac{1}{2}$ in.

Nagai, Kazumasa

Born: 1929
Medium: zinc relief

A print artist who confines himself to the color white is almost like a poet who forgoes words. Yet Nagai has convinced many people to share his fascination with the beauty of white on white. His creations can be called prints because they are multiple impressions, with zinc plates molding the relief patterns into the paper.

From the shadows of these reliefs gentle gradations of light and dark are created, so that white on white becomes something more, a play of intensities and shadows. There is also a sculptural effect, achieved by varying widths of line, in which the angle of vision plays a part in creating the image. With a certain characteristic spareness, however, Nagai's reliefs concentrate on a single basic pattern that grows and changes as the light changes with the viewer's movements. Nagai's superb control of these shifting elements is based on his own austere and persistent artistic vision.

AP. $21 \times 14\frac{3}{4}$ in.

AN. $14\frac{3}{4} \times 21$ in.

Nakayama, François (Masami)

Born: 1898
Medium: etching

As a young man Nakayama studied in France for three years, and when he returned to Japan he brought with him the little-known art of etching, along with a new French name. Oddly enough, his influence was little noted until the mid-fifties, when he first found recognition in Japan. Since then, his mastery of the technique of etching has been demonstrated in a remarkable variety of prints impressive for their delicacy of color and line, their subtlety of shading and embossing. Uncommitted to any particular style, he is capable of using several techniques in his constantly innovative etchings, all of which demonstrate the versatility of the medium and the high aesthetic sense of the artist.

His styles and subjects vary enormously, from calligraphic abstraction to spiritual evocation (Nakayama is a Christian) to fantasy. But they are united in their sense of mystery. Nakayama is more than a master of a technique; he is a master of a way of feeling. In years he is old as modern print artists go, but in his works he remains young.

Flight Toward the Infinite. $17\frac{1}{2} \times 13$ in.

Apocalypse A. $17\frac{1}{2} \times 25\frac{1}{4}$ in.

Nakayama, Tadashi

Born: 1927
Media: lithograph,
woodblock

The woodblocks and lithographs of Nakayama's early period show an interest in birds and beasts that remains in his works today. These prints were often interwoven with curving, ribbonlike forms that moved around the subject and into the background like flames. They gave the prints an unfathomable quality abstracted from reality. This treatment seemed to entangle the subject in violent action that, while artistically expressive, was emotionally frightening. In general, his colors were dark, bringing out discreet bits of metallics underneath.

More recently Nakayama's palette is sunny in tone and his subjects are shown in almost static relationships. His stylized girls and highly decorative poppies, sunflowers, and butterflies overlap in a flat space-filling arrangement. Like his favorite subject, the horse, all are printed with increasingly fine lines and additional plates of color. Fortunately, except for the fine engraving that in varying amounts overprints the gold- or silver-leaf coating in the background, Nakayama's plates are flat and maintain an overall tapestrylike unity. Had this number of plates been shaded, the facility Nakayama shows in technical ability would have resulted in visual confusion.

A Tadashi Nakayama print can be likened to a gorgeous Oriental brocade in its infinite detail, wealth of colors, and formalized patterns woven skillfully on a metallic ground.

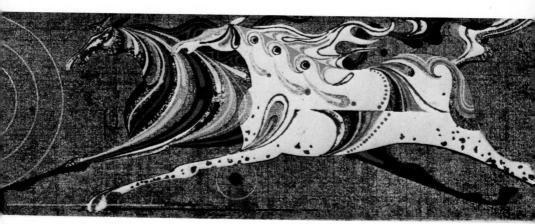

Two Dashing Horses. $9\frac{5}{8} \times 3\frac{1}{2}$ in.

Afternoon. $14 \times 18\frac{1}{2}$ in.

Dancing Horse. $19\frac{1}{8} \times 27\frac{1}{2}$ in.

Noda, Tetsuya

134

Born: 1940
Media: mixed

A young man consumed by the need to stop time, Noda has gained a reputation that belies his years. Ever since he completed his graduate studies at the Tokyo University of Fine Arts in 1965, he has been developing his visual diary, a bit-by-bit record of a life that only he comprehends—or perhaps not fully understanding it yet, he is willing to expose it pictorially.

Each of these works in mixed media describes a moment in Noda's life, with the date and usually the place as the title. At first we look at these prints in the hope of making them out, deciphering the imagery, or recognizing the scene or the people. Gradually, we understand that it is in the series itself, in contemplating a number of these works together and following their developments, that we come to know something about the man who made them—what he lived through, and perhaps why—and in doing so we come to examine our own lives, too, as a series of significant moments.

Technical versatility, flexibility, and competence mark these prints. Noda is teaching us and himself about ourselves and the world we share. His technique will no doubt reflect his growing knowledge.

Diary: Aug. 22nd '68. Detail. $32\frac{1}{4} \times 32\frac{1}{4}$ in.

Diary: June 11th '71. $16\frac{1}{2} \times 21\frac{5}{8}$ in.

Nozaki, Shinjiro

Born: 1923
Medium: silkscreen

A compulsive love of color seems to drive Nozaki, as a chemist is driven to perfect a complex new formula. Many of his series, such as *Image of Love,* are in fact systemic pieces. In that series, each print is divided into four parts that are diagonally related. In one, for instance, the color darkens from inside to out, while in its opposite the movement is from outside to in. Shapes, too, are mathematically conceived opposites, or at least they appear that way, circles becoming ovals becoming circles again. Adjacent squares consist of opposing shapes printed in greatly contrasting colors. As many as ten colors can be differentiated —five warm and five cool.

The smaller prints, too, use ten separate colors. Their vaguely flowery or anatomical shapes have an almost psychedelic intensity, though the emphasis is on relational balance, with Nozaki acting the compulsive scientist again.

73-1. 4×6 in.

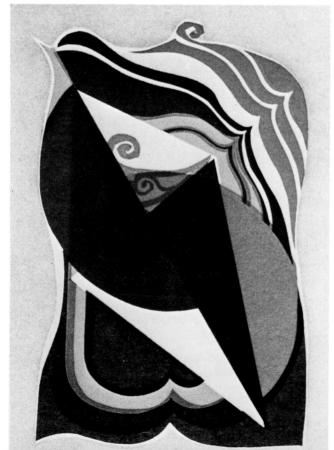

Image of Love. ▷
$10 \times 14\frac{1}{4}$ in.

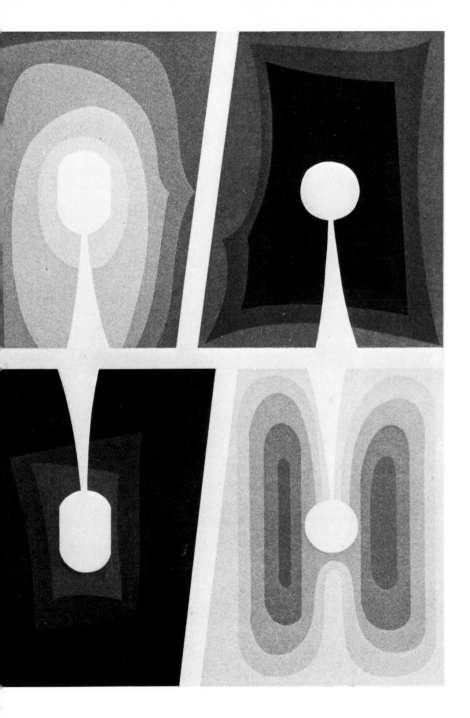

Oda, Mayumi

Born: 1941
Media: silkscreen,
Japanese stencil

What fun to be able to throw off the shackles of prejudice and play with the symbols of one's cultural heritage with abandon. In Japan a puritanical attitude toward the nude has never existed in such functional situations as the bath, even with mixed bathing. But once clothed again, the bathers may blush and display shyness and genuine embarrassment at a sexual reference.

It must have taken both courage and a playful sense of humor for Mayumi Oda to show her maidens gamboling in stark nudity at cherry-viewing time, whimsically echoing old screen paintings, or dancing over waves and other backgrounds clearly plagiarized from Japan's almost-sacred master painters. She spoofs the sex vogue with an innocence that deprives frankness of any opportunity for vulgarity.

For centuries, in Japanese art the female figure has been idealized as slender and willowy. However, Oda's bodies are voluptuously overblown, with outsized breasts and hips, which she further accentuates through the device of miniaturizing the legs and arms. Because of flat treatment and a generous use of pattern, these fun-filled cavorting women are saved from being caricatures, and through Oda's rhythmic brush they are saved from conveying the commonness of a sex symbol.

Frosted Sky. 24 × 35½ in.

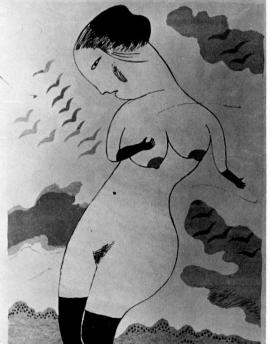

Sea Goddess. 24 × 35½ in. ▷

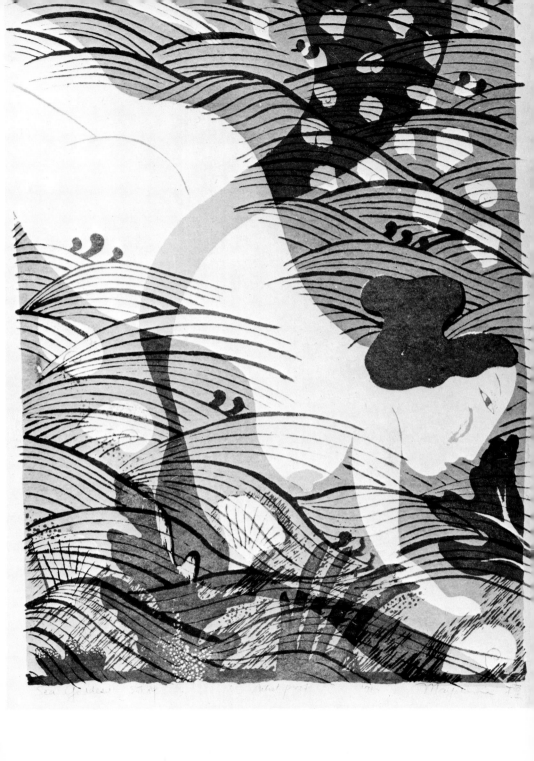

Sea Garden SJY Artist proof Mary '73

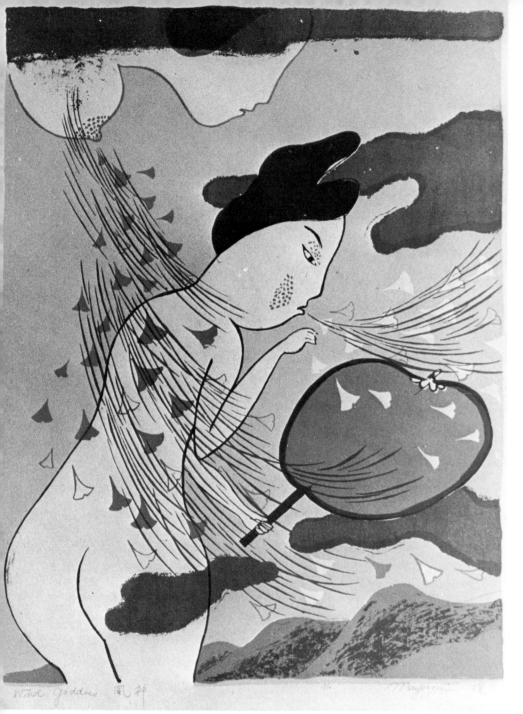

Wind Goddess. $24 \times 35\frac{1}{2}$ in.

Ohba, Masao

Born: 1928
Medium: paper screen

These are quite tiny prints, usable as room decorations. Easily recognized objects are rendered in formal patterns—a familiar plant or beetle, a lobster, a rooster—and printed in an unusual manner, using paper screens rather than silk ones. An occasional Ohba print will be large; similarly, most other print artists will occasionally publish a miniature.

By concentrating on small pieces, an artist is able to work in a limited space with all his materials within arm's reach. Ohba uses the same technique described in the section on Hiroshi Kabe, except that Ohba leaves unprinted areas free of acrylic varnish. His color combinations are as varied as his subjects. Edges are deliberately softened by extending a border of softer colors around the print.

Ohba's work is appreciated by people who enjoy designing print walls in their homes. His formalized, unassuming images hold their own when they are surrounded by more massive compositions.

Tento Mushi. $5 \times 4\frac{3}{4}$ in.

White Butterfly. $4\frac{1}{2}$ × $4\frac{1}{2}$ in.

Butterfly. $4\frac{3}{4} \times 4\frac{3}{4}$ · in.

Okamoto, Shinjiro

Born: 1933
Medium: silkscreen

These impishly clever prints are fun to contemplate. Each expresses a single, charming idea in the simplest and least contrived terms. The light, satirical portfolio of six prints collectively labeled *Gogh Time Machine* is as cheerful as it is witty: *Portrait of Gogh* is instantly recognizable, with one big artist's eye staring out of the familiar stubbly triangle of a head. In case the viewer misses the reference, a single ear can be found—quite appropriate for its singularly energetic subject.

Bandaged Self-portrait contains all the historically noted elements of Van Gogh's face: brain, teeth, eyes—placed vertically—and the pipe, surrounded by a forest of short hairs. The series, in a signed edition of one hundred, uses pale blues and yellows in friendly combinations that underline Van Gogh's love of the sun and Okamoto's good cheer.

Starlit Night. $29\frac{3}{4} \times 22$ in.

Portrait of Gogh. $22 \times 29\frac{3}{4}$ in.

Bandaged Self-portrait. $22 \times 29\frac{3}{4}$ in.

Okamoto, Shogo

Born: 1920
Medium: etching

Here is an artist who obviously loves trees in all their sinewy variety. His etchings so faithfully reproduce natural scenes as to inspire in the viewer a sense of the breezy outdoors. Preferring winter landscapes and working often in mezzotint, the artist evokes a mood refreshing to those who spend their lives in cramped, airless cities.

Leafless trees viewed looking upward create their own pattern against a cloudy backdrop. Deciduous and evergreen varieties are often contrasted to form a scene that is both velvety and delicately laced. Most realistic print artists in Japan include indigenous features such as straw-thatched roofs or latticed windows, neatly furrowed rice paddies or patches of bamboo forests. Okamoto, however, avoids these subjects, concentrating on nature as it looks without man's interference. It may be that he wants to communicate a message that beauty in nature is common to all locations and that you are free to relate his art to trees you have known wherever you live.

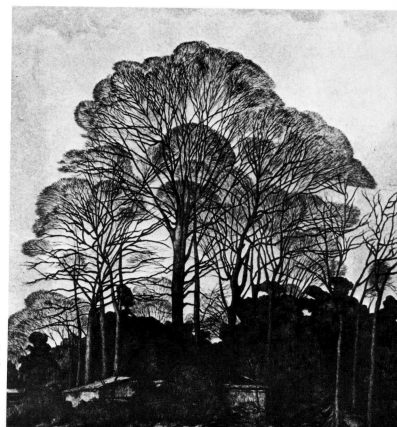

Landscape of a Slope. 14 × 15½ in.

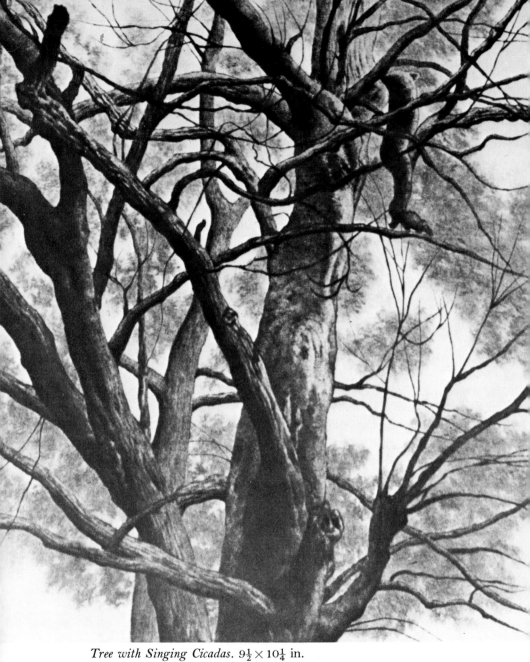

Tree with Singing Cicadas. $9\frac{1}{2} \times 10\frac{1}{4}$ in.

Approaching Darkness. $10\frac{1}{2} \times 14\frac{3}{4}$ in. ▷

Onogi, Gaku

Born: 1924
Medium: silkscreen

Onogi's color is blue. By printing with two inks of exactly the same shade and intensity, he creates patterns that are almost impossible to identify, the only variation being the degree of reflectiveness of the inks. By peering closely at what at first appears to be a plain field of a single color, the design can be gradually elucidated. Sometimes the lines of the pattern can be determined only by a slight embossing along the edges.

This is the art of understatement, simplicity so fine it is almost nothing at all. But between nothing and almost nothing there is a clear difference, which may be termed the very minimum of something. Great courage is required of the artist who confines his expression to this minimal degree of difference, but it is the courage of the poet who condenses his experience into a few simple sounds, to be understood by the patient and sensitive reader.

Onogi is a master of shading: a streak of color shaped like a sword that gradually pales into nothingness, subtle curves of gradually lightening abstract forms that develop weight and shape. The titles reveal these prints as landscapes, and indeed they may be. Even so, they are experiments in understatement.

Landscape N. E. I. 19 × 13 in.

Landscape N. E. W. $22\frac{1}{2} \times 22\frac{1}{2}$ in.

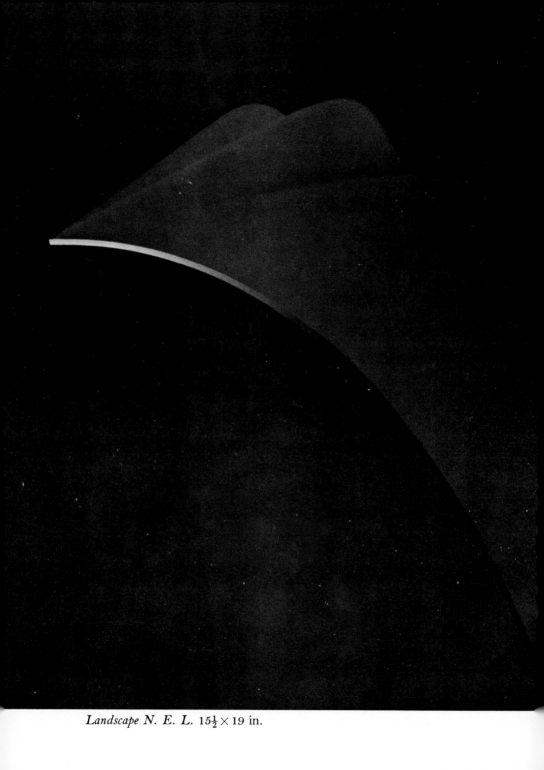

Landscape N. E. L. $15\frac{1}{2} \times 19$ in.

Onosato, Toshinobu

Born: 1912
Medium: silkscreen

Onosato came to his fascination with circles and squares not from the Op Art movement but from his background as an engineer. Thus he may be considered one of the pioneers of scientifically oriented design, with his circles within squares within triangles, overlapping and breaking into rectangles, rhomboids, cones, and other geometric forms. The whole seems to tick merrily away like some gigantic watch movement.

This artist's works force the eye to follow strong, rhythmic patterns, swinging from part to part along the tails of circles that are not unlike the comma-shapes of yin and yang, or reverberating and bouncing from point to point. The colors are chosen to emphasize these movements, which are less noticeable in black and white.

Graduating from oil painting, Onosato now devotes his energies to silkscreen prints that duplicate the themes of his oils but on a reduced scale.

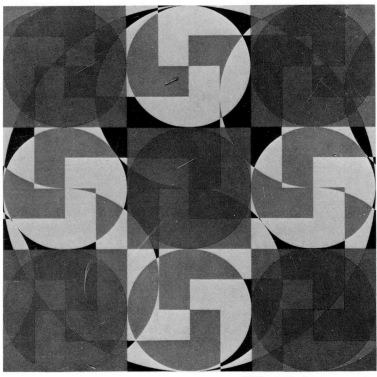

Yellow Circle. 12 × 12 in.

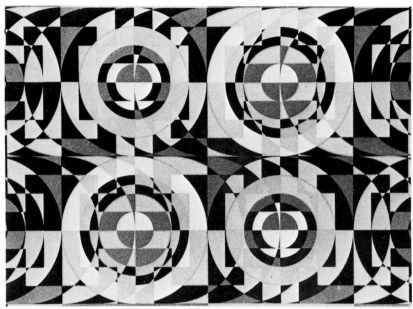

Untitled. $13 \times 9\frac{1}{2}$ in.

Untitled. $16\frac{1}{4} \times 13$ in.

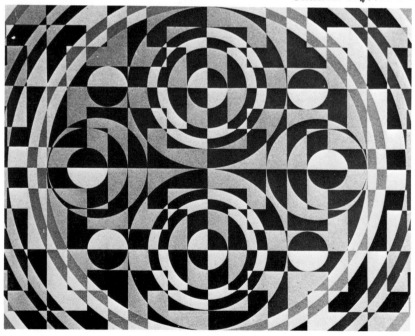

Ouchi, Makoto

Born: 1926
Medium: etching

Familiar Japanese images and designs are seen here—the red sun, Hokusai's waves, Sharaku's Kabuki actors, humorous Kyogen masks foreshortened as if pasted onto cubes. Arches and fans that themselves float in air or rest on the surface of an image are not at all inappropriate for evocations of the ukiyo-e, literally, "floating-world pictures," of Japan's colorful past.

Ouchi compresses the lapse of centuries in these pungent contemporary compositions and satirizes the ephemeral quality of time by the presence of butterflies and dragonflies that flutter incongruously along the edges of his works.

What is equally important is Ouchi's skillful use of a paper block with which he prints flat areas, simultaneously creating a low-embossed effect. This, combined with the tonal subtleties possible in etching, further emphasizes contrasts in time.

Dice. $27\frac{1}{2} \times 21\frac{1}{2}$ in.

Okame. $16 \times 19\frac{1}{2}$ in.

Utamaro. 35 × 23 in.

Saito, Kiyoshi

Born: 1907
Medium: woodblock

No list of modern Japanese woodblock artists could be made without including Saito's name near the very top, for in many ways the survival and development of the modern print is largely a result of his work and his success. Foreigners who know the names of only a few Japanese artists are likely to know Saito's, for his work has graced the walls of thousands of Western homes, carrying with it the fame of Japanese print art.

In some ways, Saito's success is a wholly postwar phenomenon. In the late forties and early fifties, foreigners—mostly Americans—by the hundreds of thousands were traipsing through Japan, visiting temples, trying the tea ceremony, attempting to fathom the significance of rock gardens. Saito's bold, graceful, simplified impressions strengthened their experience, helped make sense of stone lanterns, tiny shops, persimmon trees, temple paths—whatever it was that Japan meant in those days. Veering away from complicated symbolism, he found beauty in the harmonies of lines and spaces, the peacefulness of soft greens and rusts and blacks, the dedication to quiet that Japan so much needed then and so much needs now.

He remains active and prolific, his latest prints retaining the ease and grace that made his earlier work so clear and affectionate. There can never be another Saito, and his works are all worthy of his past accomplishment.

House in Aizu A. 29½ × 18 in.

Omuro—Kyoto. 21 × 15½ in.

Ikagurano—Sato—Horyu-ji, Nara. 21 × 15½ in.

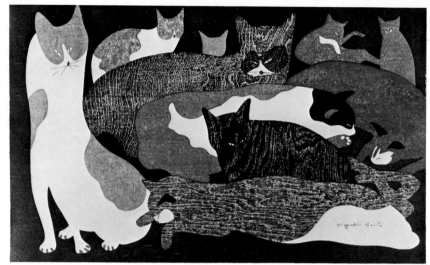

Suspicious Eyes (Saigi). $29\frac{1}{2} \times 17\frac{3}{4}$ in.

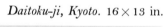

Daitoku-ji, Kyoto. 16×13 in.

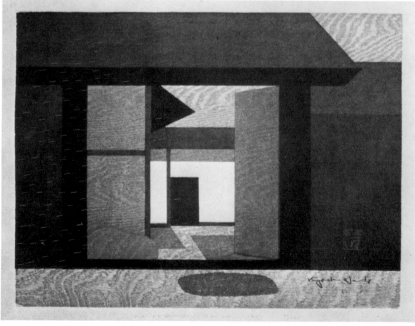

Saito, Ryo

Born: 1941
Medium: silkscreen

One of the younger print artists, Ryo Saito reflects contemporary interests in his subject matter. At the same time, his use of color and experimental form mirrors current attitudes. Some prints look as if their subjects were lit by strobes, reversing the subject in dark and light cadences and leaving a retinal afterimage. Highly theatrical, these prints add an element of movement and dazzle rarely found in silkscreens.

One series combines the female form with a wavy background that symbolizes water. The two blend, with the human bodies often seen only in outline or in translucent inks. In other earlier groups of prints, such as *Red Sun* and *Red Moon*, the emphasis is on wildly fluorescent colors less subtle than those used in the strobe effects and wave patterns. What appears most youthful about Saito's work is a restlessness that seems intent on stirring the blood.

Red Sun. 21 × 18 in.

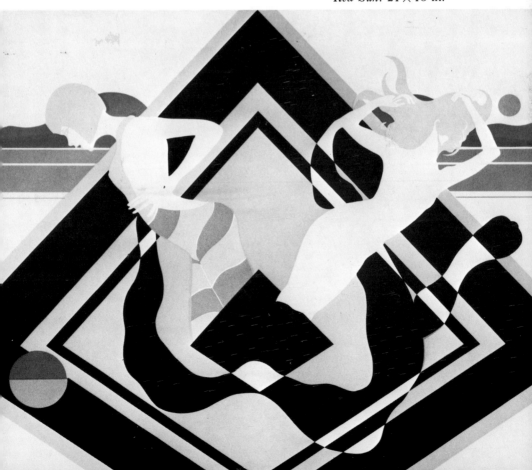

Love A. $18 \times 21\frac{1}{4}$ in.

Sakamoto, Koichi

Born: 1932
Medium: etching

These affectionate studies of nature are obviously the work of an artist who is sensitive to discovered forms as opposed to imagined ones. While the juxtaposition of shapes irrespective of size indicates a preference for dreams over reality, the fidelity to natural objects—birds' nests, snow-covered roofs, leafless trees, clouds, doves, flowers—shows a love of what exists. Thus a single print can contain a most intricate drawing of a profile, a rearing stallion, some cracked eggshells in a nest, a wintry tree, and a colored sky, and still make sense, in an odd way. The arbitrary linking of objects defines a fantasy world rooted in observed forms.

Sakamoto's draftsmanship and sharp eye are not the only sources of his skill; his secret is the rhythmic unity of his constructions, which seem somehow perfect in themselves even if they are illogical. His realism is deceptive because his moody natural scenes and carefully drawn birds and flowers exist in a dream universe that their very existence makes palpable.

Distant Sky. 14 × 8 in.

Red Space. 10 × 14 in.

One Evening. $6\frac{1}{2} \times 8$ in.

Shadow of the Sky. $7 \times 7\frac{3}{4}$ in.

Sarashina, Shu

Born: 1935
Medium: etching

Each of these engaging etchings illustrates six separate facets of a personal experience, very much like a random page from a family photo album. This would be far less interesting if the images did resemble snapshots. Instead, each collection contains an unexpected mixture of the abstract and the representational, the related and the incoherent—like real experience.

They are like pictures from a farmer's album or scenes from a rustic vacation, but with objects seldom seen in towns and villages in most of Japan—strange birds and figures with somber, perhaps impatient, expressions: forms and colors created by the artist's mind and brush. The rural images represent Sarashina's native Hokkaido, Japan's northernmost major island, and the recurring faces are no doubt those of family members.

What is most interesting from a technical point of view is the range of variation within each series—finely etched drawings are contrasted with flatly brushed symbols, which makes these etchings enjoyable to look at both singly and in groups.

Pastoral—2. $23\frac{5}{8} \times 35\frac{1}{2}$ in.

Sailing at Dawn. 23×34 in. ▷

Sasajima, Kihei

Born: 1901
Medium: woodblock

Anyone familiar with the work of two of Japan's best-known woodblock artists, Un'ichi Hiratsuka and Shiko Munakata, will inevitably find similarities in the prints of their student Kihei Sasajima. At his best, Sasajima is less literal than Hiratsuka and less imaginative than Munakata. He is, however, as masterful as his teachers in controlling the interplay of black and white to create a stark, scintillating effect. Solid areas are fragmented into dancing shards; shrubbery reflects a midday sun. What at first look like random wood chippings gradually take shape and direction as the image emerges.

Sasajima does not always use equal amounts of black and white. In some of his representations of the Buddha, for instance, the areas that define the body are predominately black or white. Some of his woodblocks are printed on a darker coffee-colored paper resembling that of old Buddhist paintings.

In order to create a three-dimensional effect Sasajima dampens a soft paper thoroughly and presses it deep into the surface of the block, bringing the embossed parts above the surface of the inked areas. This technique creates a dappled surface, adding much to the charm of these prints.

Old Tower, Falling Sun. $17\frac{3}{4} \times 23\frac{5}{8}$ in.

Aizen Niō. $17\frac{3}{4} \times 23\frac{5}{8}$ in. ▷

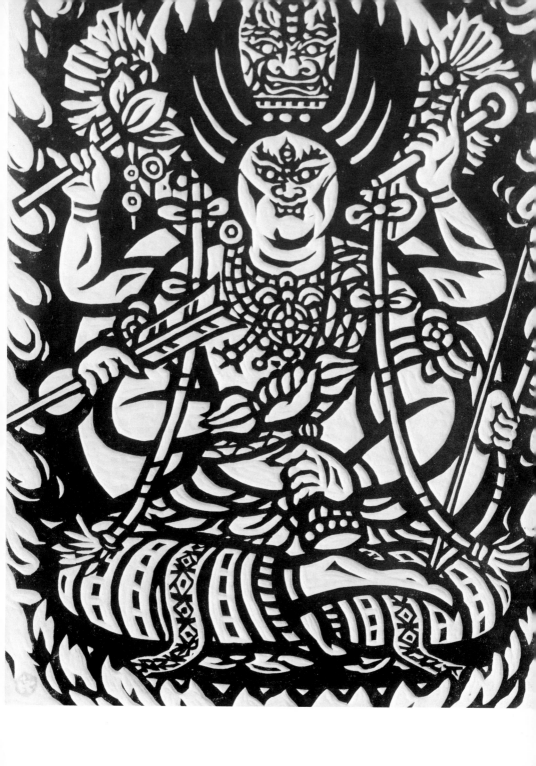

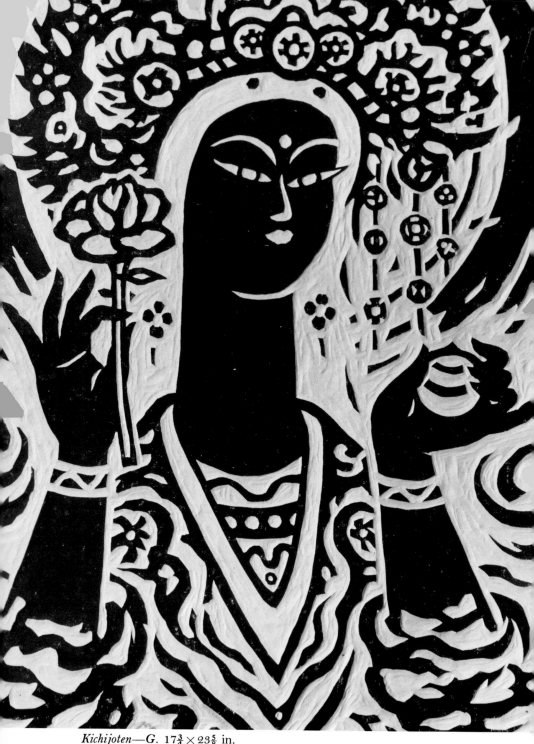

Kichijoten—G. $17\frac{3}{4} \times 23\frac{5}{8}$ in.

Sasaki, Asako

Born: 1939
Media: silkscreen, etching

These cheerful serigraphs are intended to appeal to children, which is not at all a common practice in Japan and may be said to reveal a somewhat Western attitude toward print art. The subject matter, too, is quite thoroughly Western—tables and chairs, pets, and costumes. Of course, all these are popular in Japan today, so it is not necessary for a print artist to have studied abroad to possess a fondness for things Occidental.

As a matter of fact, Sasaki did study etching in Europe, living for a time in France and Spain, and only recently turned to the silkscreen medium and children's art. Her colors seem European: a blue, minimal cat on a soft yellow ground; a many-colored print titled *Florist.* Children everywhere love vibrant colors, so this choice seems to have been a wise one. Sasaki's almost unconscious balance of forms must have been the result of a firm foundation in Oriental aesthetics; scores of Western artists have come to Japan to achieve the modern synthesis so clearly visible in these captivating prints.

Cat. $15\frac{1}{2} \times 13$ in.

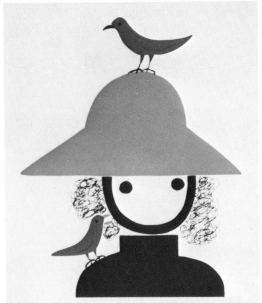

Birds and Hat. 10 × 10 in.

Florist. 15½ × 13 in.

Sato, Ado

Born: 1936
Medium: silkscreen

Sato has a talent for softening the brutality of geometric forms by combining them with crisp fine lines. He extrudes points from a circle into the corners of a square. He manipulates a candy-striped tube three-dimensionally to form a pinwheel as an eye-catcher. Through the simple device of varying the waterline seen through portholes, the roll of a ship is suggested.

Selecting a fixed framework for each composition, the artist sharply defines the harmony of the subdivisions. Sato's silkscreened colors are as precise as his designs are circumscribed.

The frame lines are clearly part of the prints, exerting a rigid, containing force on the pliable matter within. These mostly square forms are accurate and controlled, yet their crispness is tempered with a flexibility that makes the prints interesting.

Little Sergeant. 16 × 15¾ in.

Ebb Tide. $17\frac{1}{2} \times 19$ in.

La Fleur. $7\frac{1}{2} \times 11$ in.

À M.S. $56\frac{3}{4} \times 115$ in. ▷

Sawada, Tetsuro

Born: 1933
Medium: silkscreen

Inspired by the vastness of aerial space, Sawada's prints express the mood of the jet age. Peaked cloud layers deceptively appear as land masses and move the eye to a succession of new mirages. Powerful expressions—of the infinite beyond, of forward flight at smooth speed, of the silent emptiness of the universe—are condensed into one in a Sawada "airscape."

Born in the sparsely populated northernmost major island of Japan, Hokkaido, known for its clear skies and mountain vistas, and traveling at vast heights for frequent gallery exhibitions in South America, this artist's background and experience have no doubt contributed much to his very personal vision.

His moods change with the time of day, dawn, noon, or sunset, expressed mainly in a dominant color. Twenty-four screens were used to print *Night Flight*—every conceivable blue, plus pale warm lights for contrast. The silkscreen is marvelously suited to Sawada's fascination with his very special concept.

Airscape Yellow. $20\frac{1}{2} \times 16\frac{5}{8}$ in.

Night Flight. $15\frac{1}{2} \times 22$ in. ▷

Sekine, Yoshio

Born: 1922
Medium: silkscreen

The lozenge shape, as it appears in the abacus, has been part of everyday life in the Orient for a millennium or more. Even today, in the age of electronic calculators, the most sophisticated Japanese office worker has an abacus handy for quick arithmetic. Thus these shapes have a meaning in Japan that could never come through in the same way in translation to the West —every child has spent years fingering the beads, listening to the clicks as they slide into place to reveal magically the solution to any mathematical problem. To be able to lift so everyday an implement into the realm of symbol is Sekine's gift. From the mundane world of the shopkeeper, these bamboo beads strung on a rod are transformed into a window on the world.

Because the forms are so simple and regular, attention is inevitably drawn to surface qualities: variations of shiny and dull inks, white pigment of a color different from that of the paper. Some prints have a soft feel; others are made on clear plastic. People in all professions who calculate know the abacus and are fond of these evocative prints and paintings. Sekine's work has been seen several times at the Staempfli Gallery in New York. *Black and White* looks equally interesting vertically and horizontally, and in combinations, too.

324-S. $17\frac{5}{8} \times 20\frac{3}{8}$ in.

◁ 310-S. $18 \times 14\frac{5}{8}$ in.

Sekino, Jun'ichiro

Born: 1914
Medium: woodblock

Sekino's portraits of some of Japan's most famous early modern printmakers have earned him a reputation as a leading artist. The prints depicting Shiko Munakata and Koshiro Onchi, for example, are both rare and outstanding—rare because portraiture is relatively recent in modern print art and outstanding because they contain unmistakable suggestions of their subjects' work. Sekino has also made portraits of puppet-theater masters and of famous actors.

Not at all limited to portraits, Sekino has made prints of cityscapes, grain fields, animals (such as the serene *My Black Cat*, in which the pet is cradled apprehensively in a male figure's arms). Floral compositions seem to be his most recent interest.

Using a remarkable number of blocks to achieve an extraordinary color range for this medium, Sekino produces subtly colorful prints containing a seemingly infinite range of tones, as if challenging the medium to its logical limits. Sekino is one of the earliest modern print artists; his reputation today remains as impressive as his enormous output.

Six Jizo. $25\frac{3}{4} \times 18$ in.

Portrait of Onchi Koshiro. $11 \times 14\frac{1}{4}$ in. ▷

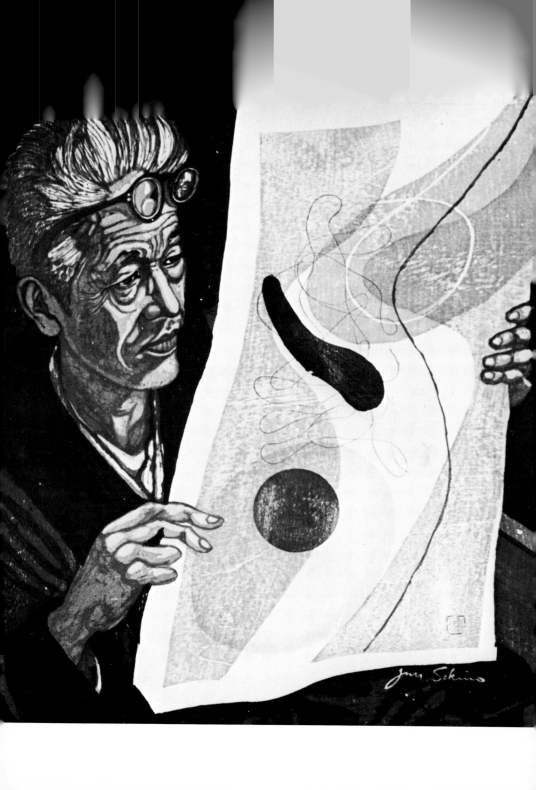

Shibuya, Eiichi

Born: 1928
Medium: etching

Instead of outlining his subjects, Shibuya sketches them with free, swirling lines and splotches that electrify otherwise quiet scenes. A city seems to be hopping restlessly about in *Sunset Village*. In his depictions of women the graceful, slender figures emerge from linear tangles and swirls.

Color and line unify these prints; the subject matter serves only as their inspiration. Broad sweeps of line or imaginative color schemes remain inevitably more memorable than Shibuya's figures and landscapes. The work thus seems both fanciful and faithful, portraits of moods rather than scenes, inviting the viewer to escape the bleaker world that flows constantly beneath the fantasy.

Left: *Clown's Daughter.* $4\frac{1}{2} \times 14\frac{1}{2}$ in. ▷

Right: *Woman in Kimono.* $3\frac{5}{8} \times 14\frac{1}{4}$ in. ▷

Sunset Village. 14×8 in.

Shinagawa, Takumi

Born: 1908
Medium: woodblock

The family crest of Japan in its thousands of variations would seem to have exhausted all the possibilities of reducing a symbol to its simplest form and relating it to the square or the circle. Following a recent trend, Shinagawa has applied sexual symbolism to his prints. Avoiding the texture, lines, or shading used by some artists, he also avoids the pitfalls that can result in vulgarity. Shinagawa's vigorous crestlike forms are drawn in strong contrast, each edge contributing to the pattern of its neighbor.

For centuries there have been common and equally abstract applications of the sex theme in the Orient, as can be observed in the ancient womb-shaped tombs of Okinawa, the copper-topped phallic rail post in Japanese temple architecture, and the ubiquitous *kokeshi* dolls. Therefore, as classic as they are modern, Shinagawa's graphics are natural, inoffensive, and, above all, good art.

Positive and Negative No. 2. 22 × 34 in.

Positive and Negative No. ▷
4. 22 × 33 in.

Positive and Negative No. 8. $21\frac{1}{2} \times 31\frac{1}{2}$ in.

Shinoda, Toko

Born: 1913
Medium: lithograph

The abstract calligraphy of Shinoda is known around the world. Her distinctive paintings and lithographs are found in leading museums and notable collections. Characteristic brush strokes overlap and angle elegantly in every Shinoda presentation, carrying into effect an ancient Oriental principle of perfection. Here not only is emptiness considered weight, but blank space is compared for shape and size—by Western standards certainly a negative approach to art analysis.

Shinoda's skillful use of the litho stone duplicates the shading of a loaded brush as it is drawn over absorbent paper, the feathery effects created as moisture is dissipated. A few crisp lines in each composition delicately offset the pull of the bolder strokes, evoking a feminine sensibility.

Here is the power of blackness amid whiteness, of strength amid subtlety. Shinoda's art is inimitable, too original to be plagiarized.

Through. 13 × 18 in.

Breeze B. $20 \times 15\frac{1}{4}$ in.

Departure. 15×20 in.

Sora, Mitsuaki

Born: 1933
Medium: woodblock

It is easy to imagine the shapes in these prints as sculptures. In *Thoughts*, for instance, four geometrically carved stones are poised like acrobats, so vividly suggesting mass and weight that we wonder if they are perfectly balanced. Will they come crashing thunderously to the ground? We await the rumble, shield our faces against the debris.

Sora is actually a sculptor who has transferred to the woodblock medium the principles he nurtured in learning the art of mass and volume. Ponderous yet delicate, his two-dimensional figures are as huge as our imaginations can make them.

A master of the chisel, Sora now works in both stone and wood. Some of his woodblock motifs dance in many colors, with a repeated form creating a cohesive rhythm. For a time the artist lived in Mexico and the United States, but now he is securely established in Japan.

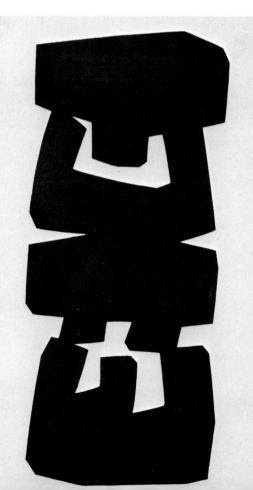

Thoughts. 11 × 22 in.

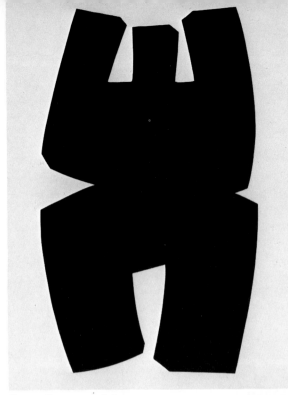

Strength. $14 \times 21\frac{1}{2}$ in.

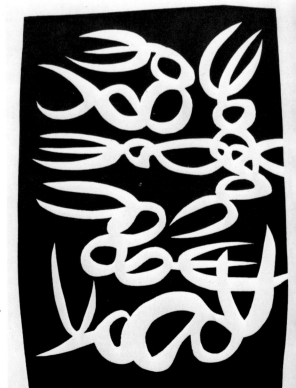

Sea. 15×22 in.

Sugai, Kumi

Born: 1919
Medium: silkscreen

Sugai, who makes his home in Paris, is considered one of the major print artists there and in his native Japan. He considers himself a painter first and foremost, but his vision seems superbly adapted to the print medium, as well. He likes the idea of selling a great many copies of his prints at very low prices— a democratic concept that should be encouraged wherever possible— and would prefer to issue large editions by mechanical means rather than rely on more expensive and exclusive hand technology.

Sugai's bold, hard-edged prints are designed with the precision of a Japanese crest. Confining himself to stark, flat colors, Sugai introduces variations in tone by a series of thin parallel lines. The objective is immediate communication, as with a glance at a familiar face— comprehension free from ambiguity.

The artist was injured in two separate automobile mishaps. From these tragic experiences he has gained an interest in immediate transmission of imagery through simplicity of color and technique. Clearly, his recent suffering has not weakened his spirit.

Variation E. $25\frac{1}{2} \times 25\frac{1}{2}$ in.

◁ *Variation G.* $25\frac{1}{2} \times 25\frac{1}{2}$ in.

Tajima, Hiroyuki

Born: 1911
Medium: woodblock

These richly colored, dark prints are produced by an incredibly complicated method that creates an inimitably luminous effect. Every Tajima work seems to glow from behind, as though it incorporated a fluorescent light shielded by a mysteriously textured fabric. That luminosity and his gorgeous color effects have brought the artist invitations to show his work all over the world. His prints may be found in numerous collections both in Japan and abroad.

Tajima's technique consists of brushing intensely colored dyes over a dark-colored medium, imparting luminosity to the white areas while enriching the basic colors of the print. The textured areas fade off into dark planes, seeming to float on a cool liquid. Thus the fascinating, bubbly shapes are set off by simple, relaxing ground forms. In the end, this rare combination of intricacy and confident simplicity makes Tajima's work both exciting and reassuring.

Bombando. 9 × 12 in.

Red Wall. 16¾ × 22 in. ▷

Takabe, Taeko

Born: 1941
Medium: etching

Childlike in their inventiveness and imaginativeness, these etchings are also refreshing in their steady avoidance of the expected. They are whimsical and bold, sophisticated and suggestive. Each is an experiment in form, in color, in drawing technique. Yet each is executed with a firm awareness of the whole. The intensities and weights of color are adjusted to the sizes of the etchings.

Takabe is an artist who is not afraid to be original; nor is she afraid to be conventional. Her long, narrow panels are unique among modern Japanese prints, yet they imitate the dimensions of traditional hanging scrolls, if only to satirize the scrolls' ponderous slenderness. Some of her prints are completely formal in design, while others are as informal as children's book illustrations, which indeed they are intended to be. If her creative flair appeals to children, it most definitely appeals to adults as well. The only certain element in each new Takabe print is that it will be utterly unlike its predecessors.

Left: *An Illustrated Book for Kiddies.* 13 × 38¼ in. ▷

Right: *An Illustrated Book for Kiddies.* 13 × 38¼ in. ▷

Child's Poem. 5¾ × 2¾ in.

Humming. $7 \times 23\frac{1}{2}$ in.

Takahashi, Rikio

Born: 1917
Medium: woodblock

These expansive prints, sometimes nearly three feet high, are surely among the largest to be found in Japan. They are products of prodigious engineering that seems to defy the limitations of their materials. The Japaneseness of these abstractions is seen not only in their often colossal size and their coy titles (such as *Tasteful-Kyoto Series*) but in their planned, careful texturing. Nothing is accidental here.

Takahashi studied under a famous teacher, Koshiro Onchi, and it is only in terms of dramatic scale that he surpasses his master. His basic material is that most modern wood of all—veneer. By partially overlapping two blocks and printing with watercolors, he creates three distinct tones. This process is multiplied ad infinitum by the addition of more blocks. In order to preserve the integrity of the colors, each block is printed partly over a white area. The darker tones are usually the result of several overlappings, but this is not always the case.

The textures, worked out in advance, enhance the translucency of the pigments. The bold, dark stripes are softened by expanses of varying hues.

Scenery Kyoto Series No. 45. 22 × 34 in.

Tasteful–Kyoto Series No. 41. 21 × 31 in.

The Face of Kyoto. 22 × 32 in.

Tamura, Fumio

Born: 1941
Medium: lithograph

Fumio Tamura dexterously composes the nude bodies of women in erotic poses. With exquisite draftsmanship, he exploits each sensuous feminine line and curve for its youthfulness, perfection, and beauty. Paradoxically, each unconventional pose and each facial expression conveys pain and fear. Is his intent to show compassion for the traditional burden of the female—the fear of pain in childbirth? The inclusion of masks and masked figures not identifiably male intensifies the ambiguity of Tamura's message.

The colored lithograph is an ideal vehicle to exhibit the expert drawing and delicate, fused coloring of Tamura's enigmatic art.

Silent Reaction. $18 \times 22\frac{1}{2}$ in. ▷

Blue Darkness. $21\frac{1}{2} \times 17\frac{1}{2}$ in.

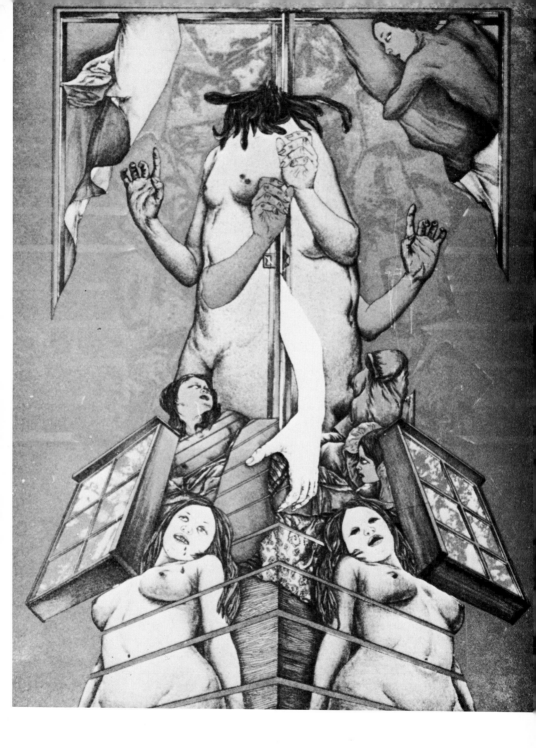

Tanaka, Ryohei

Born: 1933
Medium: etching

Much of what is most beautiful in Japan is quickly disappearing. Among these glorious ephemera are the thatched-roof farmhouses commonly seen just a few decades ago. Tanaka's minutely accurate etchings lovingly capture the memorable qualities of these roofs—a few shrubs unexpectedly sprouting amid the straw, the thatching as neat and clean as a boy's hair combed for Sunday school. Only someone who dearly loves these things could render them so honestly and with such fidelity.

Trees in these prints seem to have branches even more threadlike than real trees, so finely are they etched against a stark sky or an inclined plane of straw. Tiles, slatted window covers, latticed screens possess a reality that seems to defy the city planner's dream of turning everything into pasty poured concrete.

The colors are somber, as befits the sad loneliness of their subject: umber, black, greenish gray tones are all Tanaka needs. One can only marvel at the delicacy of these prints; they belittle photography the way an old house belittles a modern apartment complex.

Ruined Farm House. $21\frac{5}{8} \times 9\frac{7}{8}$ in.

Trees 3. $18\frac{1}{4} \times 11$ in.

Sanzen-in. $13\frac{3}{4} \times 15\frac{3}{8}$ in.

Teshima, Keisaburo

Born: 1935
Medium: woodcut

At first, these scenes of figures in landscapes seem to be quite ordinary decorative prints, a bit stark in black and white. But they are actually projections of a fertile imagination, for example, a mermaid reclining near the remains of a wrecked ship with a well-preserved angelic figurehead.

Teshima's prints have a perhaps misleading innocence to them—everything seems very loving, like the owls pecking away at a huge egg to help give birth to a flute-playing bird with a boy's face, or a warmly bundled child enjoying a ride on his icicle-covered play horse.

These are clever fantasies, but if there is something disconcerting about them too, it must be remembered that they are conceived in Japan's cold north country, the artist's home, where stark reality and dreams mix well.

Mermaid. $29\frac{1}{2} \times 22\frac{1}{2}$ in.

Owls and Child. $21\frac{5}{8} \times 29\frac{1}{2}$ in.

Toda, Yoko

Born: 1944
Medium: silkscreen

From a Western viewpoint, one of the special qualities of Oriental art is its apparent asymmetry, which uses blank areas to balance forms. In Japan, the principle is called *yohaku.* Western artists have been adopting it the way Western boxers have adopted the principles of judo: slowly and awkwardly. Toda has spent a number of years in Europe, living and studying in France and Italy, but fortunately she has not unlearned the sensibility of her native land.

These are minimalist prints, with a few carefully positioned shapes on a blank ground. A barely perceptible white line frames the ground, establishing the field. The use of complementary colors of identical intensity flattens the forms, imparting a weightlessness to their bulk.

Hard edges are softened in some prints like brush lines feathered toward the end of the stroke. As a result these serigraphs seem more alive than many hard-edged abstract prints. Though they may appear simple to create, they are inimitable. They also work well together, like ingenious attempts to answer an impossible question.

Untitled. $21\frac{1}{2} \times 15$ in.

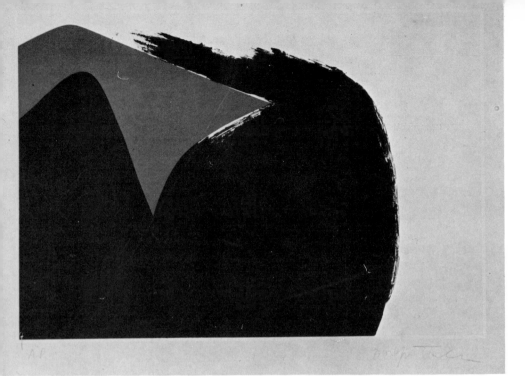

Untitled. $21\frac{1}{2} \times 15$ in.

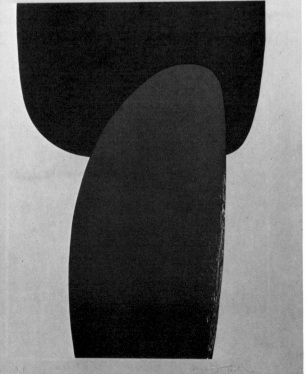

Untitled. $15\frac{1}{2} \times 21\frac{1}{2}$ in.

Togashi, Minoru

Born: 1931
Medium: copperplate intaglio

By changing one edge of a recognizable form, or by combining two forms to create a third, Togashi creates original prints of supreme simplicity. They seem electrically charged in their crisp tensions. Figure and ground dazzlingly compete and mingle; white spaces become exciting in their crisp unevenness. Nothing (and everything) is familiar here. Colors of equal lightness heighten the sense of relationship.

The use of color is unique. *Evolution S*, for example, contains a purple geometric figure in its center in which black wavy stripes slither, and the whole is enclosed in a greenish black form. Togashi loves optical illusions as well as strange color combinations. In *Evolution LXIII*, one oval appears longer than the other because of a wavy line that dissects it lengthwise. This conflicts with the circularity of its enclosure. It is like a Zen puzzle that asserts the obvious and the paradoxical at the same time.

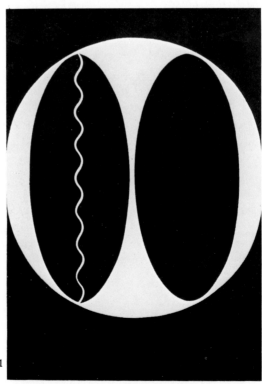

Evolution LXXXIII. 14 × 21 in.

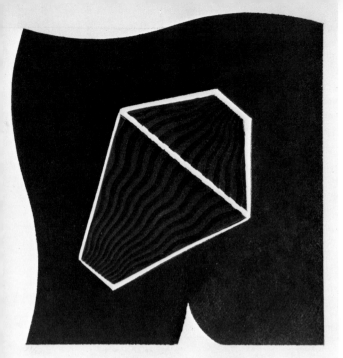

Evolution S. $8\frac{1}{2} \times 9\frac{1}{2}$ in.

Evolution LVII. $14 \times 18\frac{1}{2}$ in.

Tomihari, Hiroshi

Born: 1936
Medium: woodblock

Tomihari has borrowed a leaf from the early engravers, creating patterns in which the width of the line constantly varies. Each section of each print contains its own design, separately conceived. The patterns consist of swirls centering on dots. Combined into a whole print, the swirls interact fascinatingly, seeming to move behind and among one another or to reflect one another. Viewers can find wry or humorous faces here and there, and the expressions change as one follows the swirls or changes the angle of vision. The effectiveness of the illusion is heightened by printing one bright color per print as a ground for the carved areas and leaving white for contrast.

Sometimes they seem like stained-glass windows; sometimes they seem like Op Art monograms. By concentrating on a single technique, Tomihari has revealed the infinite possibilities of the wavy line.

Staring at Each Other. $24\frac{1}{2} \times 25$ in.

Green Man. $22\frac{1}{2} \times 23$ in.

Tomita, Fumio

Born: 1934
Medium: silkscreen

Some artists use the silkscreen medium for effects that could really be better achieved by other means. Tomita is not like this, however. Skillfully, and with great precision, he employs silkscreen to best advantage, producing large, intensely colorful prints. Bold shapes are dominated by circles containing as many as six or seven strong colors that both harmonize and clash, igniting a conflict between form and intense coloration that unifies the work rather than disintegrates it.

While it is likely that Tomita will stay with silkscreen, it is also safe to predict he will evolve new approaches and achieve new successes through constant experimentation. His latest work is a series of stylized mandala prints. While they relate to one another, the prints of this series also bear comparison with his earlier work, complementing and extending it.

A Constellation Violates the Forest 72-8. $19\frac{3}{4} \times 27\frac{1}{2}$ in.

A Constellation Violates the Forest 72-14. $14\frac{1}{4} \times 19\frac{1}{4}$ in.

Toneyama, Kojin

Born: 1921
Media: lithograph,
woodblock

Toneyama has developed a unique talent for reducing a representational motif to the absolute minimum and yet preserving its identifiable qualities —the arms and hands of a flutist executed in one unending brush stroke; a dead-white mask whose features are defined only in embossment focusing attention on the object's strange outline. Some motifs are unmistakably *haniwa* figures, clay objects found in burial mounds dating from the fourth to seventh centuries; these again show Toneyama's love for linear changes in the Japanese brush.

His serious study of primitive Mexican cultures has been the source of inspiration for many of his modern abstractions. He trims native art forms of all superficiality and creates a symbol of his own, retaining only strong derivative colors to suggest the source.

Toneyama is the author of a beautiful book profusely illustrated in color, *The Popular Arts of Mexico*, published in Japanese by Heibonsha in 1972 and again in 1974. John Weatherhill, Inc. issued the English edition in 1974.

Flute. 19 × 15 in.

Folk Art. $20 \times 14\frac{3}{4}$ in.

Top: *Minzoku.* 15 × 20 in.
Bottom: *Haniwa.* 9 × 12 in.

Tsukagoshi, Genshichi

Born: 1922
Media: stencil,
silkscreen

The technique by which Tsukagoshi achieves his uniquely mesmeric prints is in itself unique. First he silkscreens a black background. Then he cuts a paper stencil into a fine lacy pattern of the same shape as the silkscreen ground. Using the stencil and white ink, he overprints the silkscreened sheet, creating white lines through which the black can be seen.

The strongest lines in the finished print are inevitably those that have not been printed at all, the lines left blank by both the silkscreen and the stencil. These squares and circles of stark white radiate hypnotically toward a single, brilliantly enameled dot in the formal center, creating a geometric unity that integrates the delicate repeated patterns. The resulting optical effect commands the viewer's attention, which is satisfied by the subtle shadings achieved in the dual printing technique.

Carnival L. 13 × 19 in. ▷

Carnival M. 13 × 9 in.

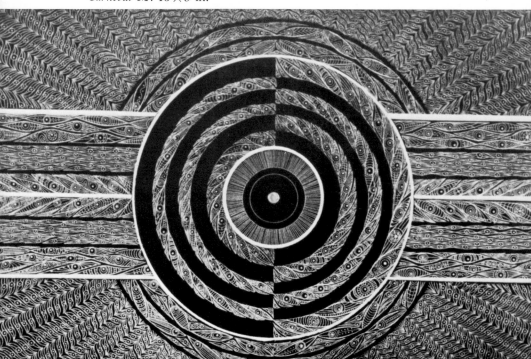

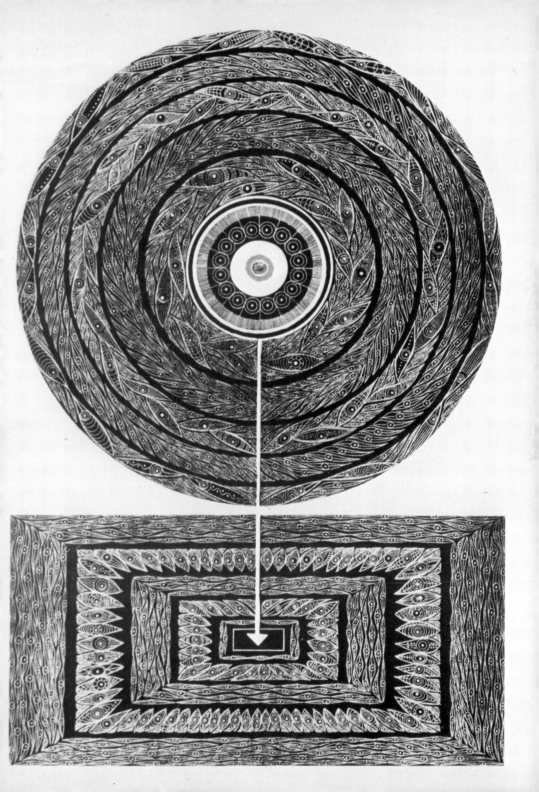

Ueno, Norio

Born: 1932
Medium: lithograph

The forms in Ueno's prints seem far removed from anything recognizable. Abstract specks and squiggles are scattered on them seemingly without reason, so that the composition appears as accidental as the shapes it contains. Yet the designs are satisfying because of Ueno's bold use of color and his truly sophisticated arrangements.

At first the shapes may be puzzling and the overall composition confusing, but the prints taken together form a comprehensible series, studies in originality and balance. *Imaginary Island* is interesting for its maplike structure. Here dark splotches are balanced with large, flat shapes, shaded areas, and forms that one might expect to find in an electronics workshop rather than a geographer's chart. In a world where so much is boringly recognizable, these prints are refreshing glimpses of a universe that never was.

Imaginary Island. 20 × 21 in.

Little Garden in Twilight. 16½ × 23 in.

Unno, Mitsuhiro

Born: 1939
Medium: woodblock

Unno manages to be both representational and unsentimental. His prints are direct and forceful, with simple lines and thrusts containing rather complex shapes that everyone who has ever been to the Orient well knows.

Drying Rice is so clean, so formal, so familiar, and yet it is really quite an involved landscape, such as one might see from a train window. Details are separated by colors but united by being placed within bands of similar value. The rice-harvesting woman is wearing a typical apron as light as the field behind it. The houses melt into the horizon, as if they were unimportant. This is a technique found in the best screens of the Edo period (1603–1868), in which representation is subordinated by avoiding contrast.

Here is a print artist who uses the abstract painter's vision to compose fully realized landscapes. The careful spacing and color values blend with the realistic subject matter and the natural hues.

Teru Teru Bozu. 10 × 13 in.

Drying Rice. 21 × 15 in.

Ushiku, Kenji

Born: 1922
Medium: etching

Ushiku's abstract etchings indicate a profound understanding of the uses of copper, acid, and ink. Generally cheerful, his colorful prints utilize a fascinating mixture of techniques. Some are printed from a single plate, while others use several plates, but in both cases the basis is a design composed of lines: lines of varying thickness, lines that expand and contract in harmony with the whole. At home with his doodles, crosshatched abstractions, he enjoys scattering solid, heavy forms into free, looping, radial lines that give these prints accent and balance, weight and speed. Amid these patterns, a few recognizable shapes can be found.

Ushiku also produces etchings that are straight realism. Whether motivated by trends or an urge to be versatile, like many artists these days Ushiku switches styles from print to print. His alternate subjects may be delicate trees and birds. Centered in the print with no attempt to show relationships in terms of design, these representational nature studies have nothing in common with Ushiku's abstract prints except perhaps the number of admirers, who seem about equally divided in favor of one or the other style.

Outbreak. Detail. 16 × 21½ in.

White Birds. $9 \times 16\frac{1}{2}$ in.

Ushiku, Mari

Born: 1924
Medium: stencil

Except that these prints do not resemble Chinese or Japanese characters, they clearly indicate a fascination with traditional calligraphy, the way of the brush. At the same time, the works seem intent on fulfilling the requirements of good design rather than symbolic significance. Alternately broad and thin strokes loop and interwine, sometimes continuing as in script, sometimes appearing to originate beyond the confines of the print.

The white areas of these prints are most interesting, for here much subtle artistry is revealed. No two white spaces are the same. All are clearly defined, rational, and interesting. This, too, is one of the objectives of calligraphy, to create satisfying white areas that ventilate and pierce but never control the forceful black strokes. It almost seems as if the artist avoids drawing familiar characters, as if that would reveal the basis of her training or impart more meaning than she intends.

Orbit 72-B. 16 × 22 in.

Orbit 71. 16 × 22 in.

Orbit 72-A. 16 × 22 in.

Watanabe, Sadao

Born: 1913
Medium: Japanese stencil

Watanabe is a Christian print artist whose subjects are invariably drawn from his religious training. His techniques, however, derive from Japanese folk traditions, never revealing the slightest Western influence in terms of illustration or design.

The folk-art movement in Japan began in the 1930s as an attempt to keep alive various traditional arts, among them stencil printing. Watanabe was an early member of a rather small but important group of artists who dedicated themselves to learning and preserving these arts, and it is largely because of their work that the techniques have survived.

Watanabe's naive interpretations evoke sincerity, but to the Westerner have charm and quiet humor as well. Only Watanabe would show the *Last Supper* with Japanese food on Japanese plates and the disciples seated without chairs—or the *Widow's Mite* as an ancient Oriental coin with a square hole. The long faces seen here are expressionless, yet the prints exude cheer and a gaiety seldom seen in religious art by Western artists.

Watanabe's biblical prints are appreciated by people of all denominations. They are said to be present in the Vatican and were hung in the White House during one recent administration. People of the Jewish faith value his treatment of Old Testament subjects. Watanabe's works are found in leading museums and in important collections from South Africa to Australia, from the Philippines to Europe.

Jesus Entering Jerusalem. 27 × 23 in.

Fountain of Meribah. 20 ▷ × 24 in.

Jesus Carrying Cross. 18×22 in.

Watarai, Junsuke

Born: 1936
Medium: etching

In his newest prints, Watarai outlines mezzotint areas with squiggly lines. The earlier etchings depended on scratches for their tonal effects. Delicately tinted, they tend to be light and happy fantasies, the colors reflecting the mood of the subjects: goats, cats, fish, people, all crowded into a strangely assembled dream landscape. The result is remarkably pastoral, like early Chagall. An occasional flute player or other musician can be found, as well as incongruous fish and flowers. The scroll of a cello can become a fish's eye on examination, with fresh images emerging all the time.

The pleasure of these etchings lies in their playful good humor, their friendly incongruence. Here is a varied, crowded, essentially good-natured universe, nicely tinted.

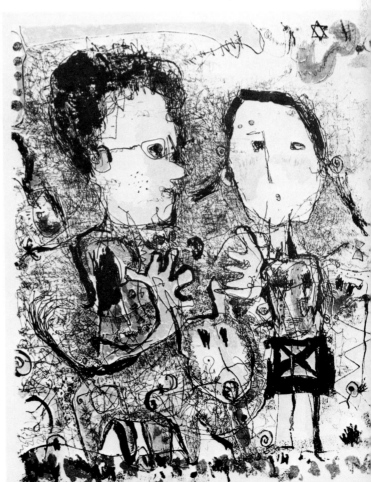

Conversation. $14\frac{1}{4} \times 17\frac{3}{4}$ in.

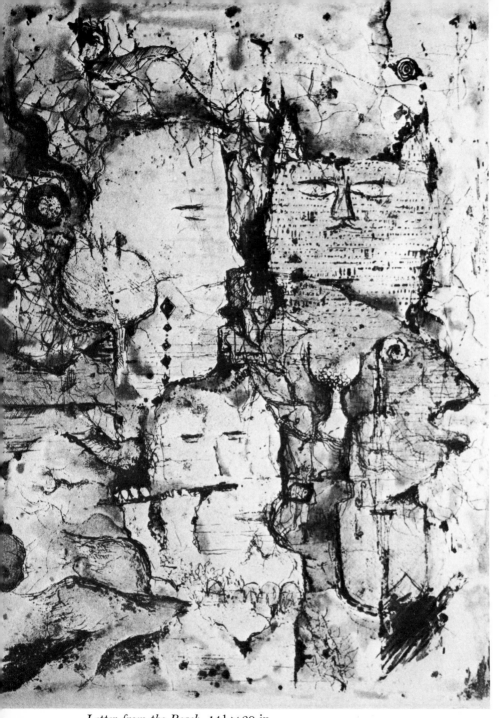

Letter from the Beach. $14\frac{1}{2} \times 20$ in.

Yamaguchi, Osamu

Born: 1918
Medium: stencil

These stencils are made in the manner of Okinawan textile patterns in a much-loved technique known as *bingata*, made famous in Japan by Keisuke Serizawa, who studied the art in Okinawa and imported it to his native Tokyo. In this method, a single stencil is used but two or more colors are printed through it, sometimes overlapping to create another color. Depending on how they are brushed on, the pigments can blend horizontally or vertically. Here they go in both directions, resulting in subtly graded colors that seem to surpass the confines of print technology.

This is a simple process, really, but a time-consuming one. Its primitiveness is matched by the primitive subject matter, which gives the prints a clean, seemingly effortless charm. Yamaguchi reduces the subjects to the simplest recognizable elements. Similar results may be seen in children's art, but this is the art of a sensitive man reaching for a childlike clarity.

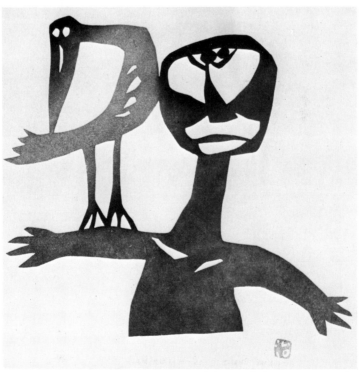

Man and Crow. $16\frac{1}{2} \times 17$ in.

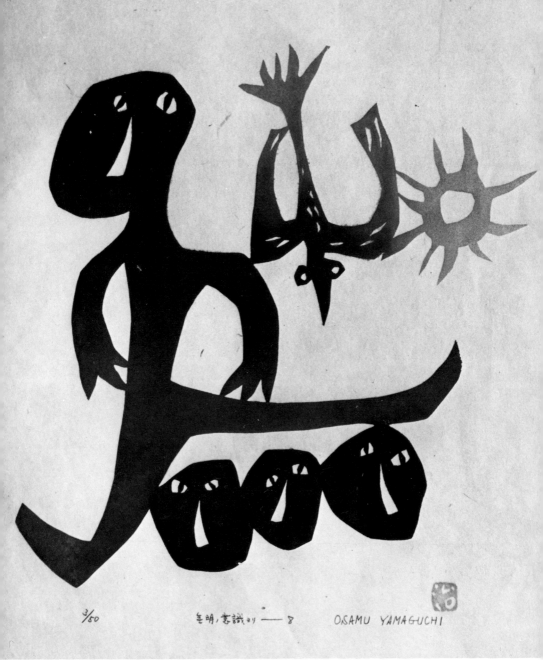

3/50　　　　年明,書識リ——8　　　OSAMU YAMAGUCHI

Boy, Crow, and Three Faces. 20 × 24½ in.

Yamanobe, Yoshio

Born: 1936
Medium: etching

The etchings of Yamanobe are easily identified by the presence of a single head, that of a bearded, bald, earnest-looking man. The upper part of the face looks not unlike a hot-dog bun, with only the slightest suggestions of squinting eyes and a water drop of a nose. The mouth is absolutely expressionless, as on a sleeping face. Prints containing these heads often evoke chuckles from viewers; there is something undeniably humorous about them. Perhaps part of the reason is that the titles are all the same: *Mustache Man.*

That is not the entire reason for the lightheartedness of these dark, strange etchings. The owner of the face has a stoic courage, refusing to react to annoying insects or tiny, cricketlike creatures that bore into his skull or ascend into space on a length of hair. The fingers of a tormentor appear in the prints too, at times, appearing perfectly ordinary in contrast to the Buddhalike, accepting face, a perverse touch suggesting a scientific experiment conducted by a sadist.

Well, we might as well smile, for what else is there to do?

Mustache Man # 30. $23\frac{5}{8} \times 17\frac{3}{4}$ in.

Mustache Man # 32. 23⅝ × 17¾ in.

Mustache Man # 33. 23⅝ × 17¾ in.

Yamaoka, Peter

Born: 1948
Medium: lithograph

The lithographs of Peter Yamaoka have attracted attention because of their academically brilliant drawing technique as well as their contemporary air of sharp sophistication. He seems to possess an inherent gift for classical Oriental arrangements, and this he unites with a vivid sense of actuality, a feel for the weighty density of objects.

He can be witty as well as graphic, with hands or with objects as inanimate as hats and sunglasses. At the same time, he can be deeply serious, as in his reflections on the tragic death of Yukio Mishima.

Yamaoka studied in the United States at the Rhode Island School of Design, and in England at the Royal College of Arts in London. He has had several one-man shows in London, now his home, and has participated in a group show for promising young artists at the Institute of Contemporary Arts there. Group shows in Bologna and Rome have also included examples of his work.

Hands. Detail. $21\frac{1}{2} \times 29\frac{1}{4}$ in.

Spectacles. $20\frac{1}{2} \times 28\frac{1}{2}$ in.

Yayanagi, Tsuyoshi

Born: 1933
Media: etching,
silkscreen

Imagination and study are necessary if one hopes to decipher the images in Yayanagi's abstruse, hard-edged, daringly colored works. Animal and human figures are placed on a ground delineated by architectural forms: planes and T-squares, boxes and archways. These prints are exciting abstractions, absorbing the viewer and drawing him in by their intricacy, challenging the imagination.

Black and white stripes, a Yayanagi hallmark for years in painting and in graphics, are appropriate in his African prints and give a powerful, dazzling contrast to the more recent *Zodiac* series. The latter are either magical or derisive, depending on the interpretation. But in either case their intensity cannot be denied. It is achieved by combining pattern and color in a manner both vivid and puzzling.

Le Taureau. $20 \times 13\frac{1}{2}$ in.

Journal des Animaux Préférés (V). $19\frac{1}{2} \times 29$ in.

Yoshida, Hodaka

Born: 1926
Media: woodblock, intaglio

Yoshida's father was famous as a woodblock artist half a century ago, and his mother, elder brother, and wife are all active artists, so Hodaka's development can be seen as a direct extension of the family tradition, by no means unusual in Japan. An undisputed leader in the print movement, the younger Yoshida gained notice first for his abstract woodblocks and only recently turned to the newer techniques for combining woodblock with photoengraving. In the course of this evolution his abstractions have been exchanged for representational forms.

At first glance, this artist's newest works seem to be a reversion to his father's subject matter, but on closer examination it becomes clear that his landscapes are cleverly constructed montages of unrelated objects: a reclining figure is an island in a calm sea; a striped robe has the appearance of a cultivated slope. A unity of nature and man results from an apparent clutter of heterogeneous photos, truly a human landscape.

Through his constant experimentation with new forms and techniques, Yoshida maintains his reputation and in the process that of his illustrious family, as well.

Paradise # 3. Detail. 16½ × 22 in.

Landscape Q. $18\frac{7}{8} \times 14\frac{1}{8}$ in.

Yoshida, Kazue

Born: 1948
Medium: etching

Anyone writing a book on the women's liberation movement in Japan might consider illustrating it with the etchings of Kazue Yoshida. Possessing both a sound knowledge of female anatomy and a sensitivity to the tensions faced by women in modern society, she manages to create works that are graceful and rhythmic. The intricacy of the details suggests an exquisite fascination with folds, waves, ripples, the tentacles of seaborne beasts, the petals of fluttering flowers: all very feminine, indeed. Drowning in undulating emotion, consumed by fierce flames, the nudes in these prints do not seem masters of their fate—at least not yet.

They are not defeated, either. The passive faces and firm loins of these figures seem capable of countering the swirling forces in which they are mired. Their tension bespeaks the possibility of change. The titles read like slightly puzzling battle cries: *Self-supporting Indulgence, Erosion and Defense*. They are challenges rather than conclusions.

Distance to the Center—II. $17\frac{1}{2} \times 17\frac{1}{2}$ in.

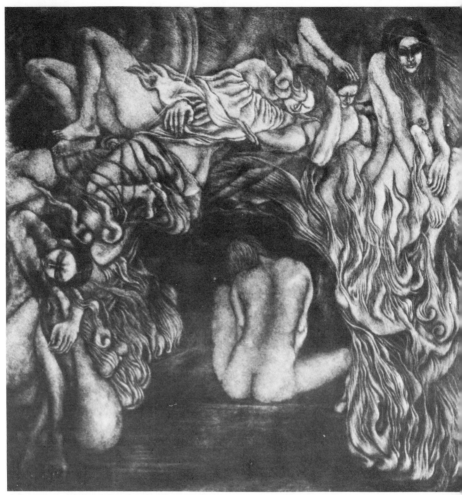

Pleasure and Satisfaction. $17\frac{1}{2} \times 18$ in.

Yoshida, Masao

Born: 1935
Medium: etching

Fertile imaginations often express themselves in a combination of realism and fantasy. The artist's skill in this is exhibited by his ability to compel logic to the point of absurdity, to be simultaneously original and mysterious, sophisticated and homely. By these standards, Yoshida is a transcendent creator whose works are extraordinary both in concept and execution. In them, trees bear peculiar fruit, faces and costumes are studded with mysterious ornaments, figures are propelled hauntingly. Absurd to the point of constructing a logic all their own, Yoshida's etchings are compelling.

The artist's skill is seen above all in his painstaking use of color to heighten the fantastic effect. Lavenders, olives, grays, ochers, and blues in unique combinations complement his fertile vision. The result is a luxurious pageant of stylized and decorative elements.

Falling Angel. $17\frac{3}{4} \times 14$ in.

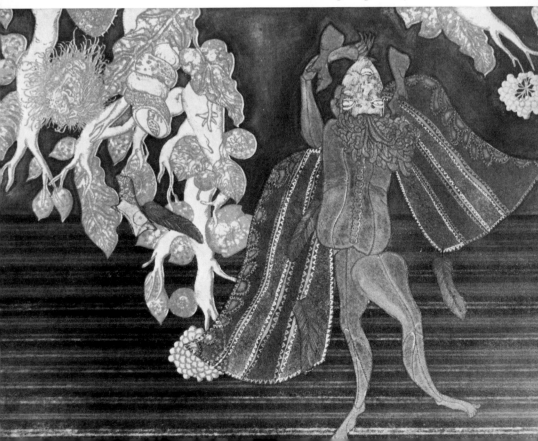

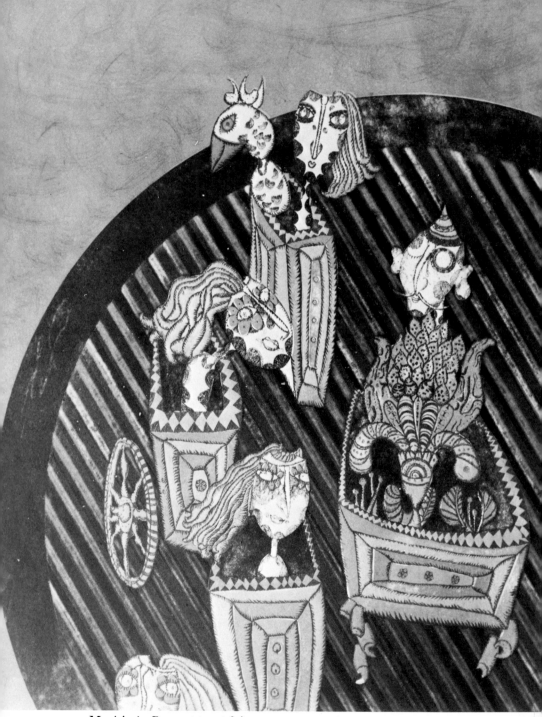

Magician's Boxes. $14 \times 17\frac{3}{4}$ in.

Yuki, Rei

Born: 1928
Medium: woodblock

These airy, generous prints are delicate fantasies, scenes of a landscape that can exist only in the imagination. The texture of the woodblock itself creates dappled tones and fragile shades. The works are light, yet the source of the light is hidden behind fences and arches. It is a light defined by shadows, creating a mood of timeless suspension.

Leafless branches cast foreground shadows, mysteriously real and abstract, stark and delicate. The texture of the block, structural unity of the geometric ground figures, subdued coloration and shading, and magical, waving forms together create a locus, a place that is both definite and infinite, haunting and unassuming, vague and too vivid to be mere fantasy.

White Arcade. 17 × 15 in.

Architectural Plane. 15 × 18 in.

In compiling a listing such as this there is always a danger of omitting deserving names. If such oversights have occurred below, they were not intended. Nor, where information is incomplete, is it the fault of the group of dedicated workers who spent days patiently checking and translating the artists' replies to the questionnaire on which much of this index is based. Some artists did not answer in full for reasons of incomplete personal records, inaccessible data, hesitancy to generalize, or perhaps even modesty. Regional variations in nomenclature in the Japanese language may also account for a few discrepancies. In a few cases, as indicated by a lack of data in an artist's entry, the only information obtainable on the artist was the inclusion of his name in some membership listing (which may well be out of date by now).

In a field as active as Japanese print art, not a month passes that new editions, new awards, and new talents do not appear. The following much-needed compilation, with all its shortcomings, is offered as a beginning in the full knowledge that it will change, expand, and hopefully grow into a useful tool for art lovers.

A few explanations of the categories and abbreviations used:

Asterisk (*) before name—artist included in main text

Med.—the principal medium or media in which the artist works

Ed.—size of edition, i.e., approximate number of copies the artist makes of each print design

Member—the art association(s) of which the artist is a member. If this category is not shown, the artist is presumed to work independently of associations. The principal Japanese associations are:

J. Print Assn.—Japan Print Association (Nihon-hanga-kyokai) established 1931. New members are elected as Associate Member and often do not become Regular Member until many years later. Sponsors an exhibition annually in April, which is open to all printmakers, subject to jury selection.

Kokuga-kai—established 1926. New members must be recommended by an active member and will have to wait ten years to progress from Associate to Regular Member. Sponsors an exhibition annually in May, which is open to all artists, all media.

Shunkyokai—established 1922. After five years as Associate Member, new members progress to Junior and then Regular Member. Sponsors

an exhibition annually in April, which has been open to painting and prints but now shows a trend toward etching.

Int.—international exhibitions in which the artist has participated. Some exhibitions are held at regular intervals, others have no established frequency, and some include media other than prints. Most competitions invite a limited number of distinguished artists from selected countries to submit work. Though there are many international exhibitions, the best-known among them are:

CCAC—California College of Arts and Crafts World Print Competition, San Francisco

Krakow—Krakow International Print Biennial, Poland

Ljubljana—Ljubljana International Print Biennial, Yugoslavia

Lugano—Lugano International Print Biennial, Switzerland

Paris—Paris International Print Biennial, France

São Paulo—São Paulo Biennial, Brazil

Tokyo—International Biennial Exhibition of Prints in Tokyo, Japan

Venice—Venice Biennial, Italy

Pz.—prize won

Aigasa, Masayoshi (1939–). *Med.:* etching, other. *Ed.:* 30. *Member:* J. Print Assn.

Aizawa, Koji. *Member:* other.

Akagawa, Isao (1940–). *Med.:* woodblock. *Ed.:* 30.

Akaiwa, Kenzo (1924–). *Member:* Kokuga-kai.

Akimoto, Yukishige. *Med.:* woodblock, silkscreen. *Ed.:* 40. *Int.:* São Paulo, Tokyo.

*Akiyama, Iwao (1921–). *Med.:* woodblock. *Ed.:* 100. *Member:* other.

Akiyama, Shizuka.

*Akiyama, Taikei (1927–). *Med.:* woodblock. *Member:* J. Print Assn.

*Amano, Kazumi (1927–). *Med.:* woodblock. *Member:* J. Print Assn., other. *Int.:* Krakow, Ljubljana, Lugano (*pz.*), Paris, São Paulo, Tokyo (*pz.*). Lives abroad.

*Amano, Kunihiro (1929–). *Med.:* woodblock. *Ed.:* 50. *Member:* J. Print Assn., Kokuga-kai. *Int.:* Krakow, Ljubljana, Lugano, Paris, São Paulo, Tokyo.

Ando, Futaba (1946–). *Med.:* woodblock, lithograph. *Ed.:* 20. *Member:* other.

Aoyama, Kosuke. *Med.:* woodblock, lithograph, silkscreen. *Ed.:* 30. *Member:* independent. *Int.:* Krakow (*pz.*), Paris.

Araki, Tetsuo (1937–). *Med.:* etching. *Ed.:* 50. *Member:* independent. *Int.:* Krakow (*pz.*). Studied abroad.

Arichi, Yoshito (1949–).

Aruga, Yutaka (1922–). *Med.:* other. *Ed.:* 50. *Member:* independent.

Asano, Takeji.

Aso, Hanaji. *Member:* J. Print Assn.

*Ato, Sengai (1929–). *Med.:* paper screen, stencil, other.

*Ay-O (1931–). *Med.:* woodblock, lithograph, silkscreen, etching. *Ed.:* 100. *Member:* independent. *Int.:* Krakow (*pz.*), São Paulo (*pz.*), Tokyo (*pz.*), Venice. Studied abroad. Lives abroad.

Azechi, Takuji (1948–). *Med.:* woodblock.

*Azechi, Umetaro (1902–). *Med.:* woodblock. *Ed.:* 150. *Member:* J. Print Assn., Kokuga-kai (*pz.*). *Int.:* Lugano, São Paulo, Tokyo.

Azumaya, Takemi (1948–).

*Baba, Kashio (1927–). *Med.:* woodblock, lithograph, etching. *Ed.:* 50. *Member:* J. Print Assn.

Bando, Soichi (1937–). *Med.:* etching, other. *Ed.:* 35. *Member:* J. Print Assn., Shunkyokai. *Int.:* Krakow, Tokyo.

Chuma, Yasufumi (1939–). *Med.:* lithograph, other. *Ed.:* 30.

Deguchi, Marie.

Dobashi, Jun (1910–). *Med.:* woodblock, lithograph, etching. *Int.:* Tokyo. Studied abroad. Lives abroad.

Dobashi, Kozo (1946–). *Med.:* silkscreen. *Ed.:* 20. *Member:* J. Print Assn.

Domoto, Hisao. *Med.:* silkscreen. *Ed.:* 35. Studied abroad.

Ei, Kyu (1911–60). *Med.:* lithograph, etching. *Int.:* Tokyo.

Endo, Akira (1939–). *Med.:* woodblock. *Ed.:* 10. *Member:* J. Print Assn.

Enokido, Maki (1938–). *Med.:* lithograph, etching. *Ed.:* 30. *Member:* J. Print Assn. (*pz.*). *Int.:* São Paulo, Tokyo. Studied abroad.

Enokura, Yasuji (1942–). *Med.:* silkscreen. *Member:* independent. *Int.:* Paris. Studied abroad.

Enomoto, Michiko. *Member:* J. Print Assn.

Eto, Masao (1919–). *Med.:* woodblock. *Ed.:* 30. *Member:* other.

Fukazawa, Gunji.

*Fukazawa, Shiro (1907–). *Med.:* silkscreen. *Ed.:* 50. *Member:* independent. *Int.:* Krakow (*pz.*), Ljubljana, Paris, Tokyo.

Fukazawa, Yukio (1924–). *Med.:* etching. *Ed.:* 2. *Member:* J. Print Assn., Shunkyokai (*pz.*). *Int.:* Lugano, São Paulo, Tokyo.

*Fukita, Fumiaki (1926–). *Med.:* woodblock. *Ed.:* 50. *Member:* J. Print Assn. *Int.:* Krakow, Ljubljana, São Paulo (*pz.*), Tokyo.

Fukuchi, Yasushi. *Member:* other.

Fukui, Michi (1940–). *Med.:* woodblock. *Ed.:* 5. *Member:* other.

Fukui, Yabuki (1922–). *Med.:* lithograph, etching. *Int.:* Ljubljana, Tokyo.

Fukushima, Ichiro (1920–). *Med.:* woodblock. *Ed.:* 75. *Member:* J. Print Assn. *Int.:* Krakow.

Funai, Yutaka (1932–). *Med.:* silkscreen. *Ed.:* 30. *Int.:* Krakow.

*Funasaka, Yoshisuke (1939–). *Med.:* woodblock, silkscreen. *Ed.:* 25. *Member:* J. Print Assn. *Int.:* Ljubljana, Tokyo.

Furukawa, Ryusei. *Med.:* woodblock. *Member:* J. Print Assn., Shunkyokai.

Furuno, Yoshio. *Member:* J. Print Assn.

Futami, Shoichi (1932–). *Med.:* etching. *Ed.:* 30. *Member:* J. Print Assn., Shunkyokai.

Hagiwara, Hideo (1913–). *Med.:* woodblock, lithograph, etching, stencil. *Ed.:* 50. *Member:* J. Print Assn. *Int.:* Krakow, Ljubljana (*pz.*), Lugano (*pz.*), São Paulo, Tokyo (*pz.*).

Hamada, Chimei (1917–). *Med.:* woodblock. *Member:* J. Print Assn., independent. *Int.:* Lugano (*pz.*), São Paulo, Tokyo (*pz.*).

Hamaguchi, Yozo (1909–). *Med.:* etching. *Member:* J. Print Assn. *Int.:* Lugano (*pz.*), São Paulo (*pz.*), Tokyo, Venice. Lives abroad.

Hara, Mami (1946–). *Med.:* etching. *Ed.:* 15.

*Hara, Takeshi (1942–). *Med.:* lithograph, silkscreen, etching, other. *Ed.:* 30. *Member:* other. *Int.:* Paris (*pz.*), Tokyo (*pz.*).

Harikae, Shoji (1914–). *Med.:* silkscreen, etching. *Ed.:* 20. *Member:* Kokuga-kai.

Hasegawa, Kiyoshi (1891–). *Med.:* woodblock, etching. *Member:* J. Print Assn., Shunkyokai. *Int.:* Tokyo. Studied abroad. Lives abroad.

Hasegawa, Makio. *Med.:* silkscreen, etching, stencil. *Member:* J. Print Assn.

Hasegawa, Masako (1913–). *Med.:* silkscreen. *Ed.:* 10. *Member:* other.

Hasegawa, Tomisaburo (1910–). *Med.:* woodblock. *Member:* J. Print Assn., Kokuga-kai, other.

Hashimoto, Kiyoshi (1930–). *Med.:* etching. *Ed.:* 50. *Member:* J. Print Assn.

Hashimoto, Okiie (1899–). *Med.:* woodblock. *Ed.:* 80. *Member:* J. Print Assn., Kokuga-kai.

Hasumi, Yukio (1927–). *Med.:* woodblock. *Ed.:* 50. *Member:* other.

Hatsuyama, Shigeru (1897–19??). *Med.:* woodblock. *Member:* J. Print Assn.

Hayasaka, Sotaro. *Med.:* woodblock, silkscreen, stencil.

Hayashi, Michiko.

Hayashi, Takashi. *Med.:* silkscreen. *Ed.:* 20.

Hayashi, Tomiko.

Henmi, Nagisa (1932–). *Med.:* woodblock, silkscreen. *Ed.:* 10. *Member:* J. Print Assn.

Hiraga, Kei. Lives abroad.

Hirano, Masafusa (1936–). *Med.:* etching. *Ed.:* 20.

Hirata, Hiroshi (1935–). *Med.:* other. *Ed.:* 20. *Member:* other.

Hiratsuka, Un'ichi (1895–). *Med.:* woodblock. *Ed.:* 25. *Member:* J. Print Assn., Kokuga-kai. *Int.:* Tokyo.

Hirayama, Michiko. *Member:* Kokuga-kai.

Hirose, Toshie.

Hiwazaki, Takao (1941–). *Med.:* woodblock, etching. *Ed.:* 50. *Member:* J.
Print Assn. *Int.:* Tokyo.
Honda, Shingo. *Med.:* silkscreen. *Ed.:* 30. *Member:* independent.
*Horie, Ryoichi (1943–). *Med.:* woodblock. *Ed.:* 10. *Member:* J. Print
Assn.
Horii, Hideo (1934–). *Ed.:* 30. *Member:* J. Print Assn. *Int.:* Krakow,
Ljubljana.
Horiuchi, Kazuko. Lives abroad.
*Hoshi, Joichi (1913–). *Med.:* wood engraving, woodblock, stencil. *Ed.:*
80. *Member:* J. Print Assn., Kokuga-kai (*pz.*). *Int.:* São Paulo. Studied
abroad.
Hosoda, Masayoshi. *Med.:* etching. *Ed.:* 30. *Member:* J. Print Assn.

Ichihara, Arinori (1910–). *Med.:* other. *Member:* Kokuga-kai, independent.
Int.: Tokyo.
Ichikawa, Sadao (1921–). *Med.:* woodblock, lithograph. *Ed.:* 10. *Member:*
J. Print Assn. (*pz.*). *Int.:* Krakow.
*Ichinose, Masako (1937–). *Med.:* lithograph, etching, other. *Ed.:* 30.
Studied abroad.
Iizuka, Hachiro (1928–). *Med.:* silkscreen. *Ed.:* 20. *Int.:* Tokyo.
*Ikeda, Masuo (1934–). *Med.:* woodblock, silkscreen, etching. *Member:*
independent. *Int.:* Krakow (*pz.*), Ljubljana, Paris (*pz.*), Tokyo (*pz.*),
Venice (*pz.*).
*Ikeda, Shuzo (1922–). *Med.:* woodblock. *Ed.:* 100. *Member:* J. Print Assn.
(*pz.*).
Imai, Norio (1946–). *Med.:* silkscreen. *Member:* other. *Int.:* Paris, Tokyo.
Imai, Yuoko. *Med.:* silkscreen. *Ed.:* 20.
Inaba, Haruo (1931–). *Med.:* silkscreen. *Ed.:* 50. *Member:* other. *Int.:*
Tokyo.
Inaba, Saburo (1902–). *Med.:* etching. *Member:* J. Print Assn. *Int.:* Tokyo.
Lives abroad.
*Inagaki, Tomoo (1902–). *Med.:* woodblock, stencil. *Member:* J. Print
Assn., Kokuga-kai (*pz.*), Shunkyokai. *Int.:* Paris, Tokyo.
Inoue, Kozo (1937–). *Ed.:* 50. *Member:* independent. Studied abroad.
Inoue, Toshio (1943–). *Med.:* other. *Ed.:* 20. *Member:* J. Print Assn.
Inoue, Toyohisa. *Member:* J. Print Assn.
Ishida, Michihiko. *Member:* J. Print Assn.
Ishii, Tsuruzo (1887–). *Med.:* woodblock, lithograph, stencil. *Member:*
J. Print Assn., Shunkyokai.
Isobe, Yukihisa (1936–). *Med.:* lithograph, silkscreen, etching. *Ed.:* 50.
Int.: Ljubljana, São Paulo. Lives abroad.
Ito, Ben (1917–). *Med.:* woodblock, stencil. *Member:* J. Print Assn. (*pz.*),
Kokuga-kai (*pz.*).
Ito, Masando (1906–).
Ito, Masato. *Med.:* woodblock. *Member:* J. Print Assn.

Ito, Masumi (1923–). *Med.:* woodblock. *Ed.:* 30. *Member:* J. Print Assn.

Ito, Wako (1945–). *Med.:* etching. *Ed.:* 50. *Member:* J. Print Assn. Studied abroad.

Itoh, Ben. *Med.:* woodblock. *Ed.:* 5. *Member:* J. Print Assn.

Itoh, Yoshio. *Med.:* woodblock, stencil. *Member:* other.

*Iwami, Reika (1927–). *Med.:* woodblock. *Ed.:* 50. *Member:* J. Print Assn., Kokuga-kai (*pz.*). *Int.:* Paris.

*Iwashita, Yo (1917–). *Med.:* woodblock, stencil. *Ed.:* 50. *Member:* other.

Iwata, Kakutaro. *Med.:* woodblock. *Ed.:* 25. *Member:* J. Print Assn.

*Iwata, Kiyoshi (1940–). *Med.:* woodblock, stencil. *Ed.:* 20. *Member:* Kokuga-kai.

Izumi, Shigeru (1922–). *Med.:* lithograph, etching. *Member:* independent. *Int.:* Tokyo (*pz.*). Lives abroad.

*Kabe, Hiroshi (1926–). *Med.:* paper screen. *Ed.:* 50. *Member:* other.

Kagoshima, Ippei. *Med.:* silkscreen. *Ed.:* 30. Studied abroad.

Kai, Sachi. *Med.:* etching. *Ed.:* 20. *Member:* Shunkyokai.

Kamachi, Seiji.

*Kamiya, Shin (1942–). *Med.:* silkscreen. *Ed.:* 20. *Member:* J. Print Assn. *Int.:* CCAC (*pz.*), Ljubljana, Tokyo.

*Kanamori, Yoshio (1922–). *Med.:* woodblock, other. *Ed.:* 30. *Member:* J. Print Assn., Kokuga-kai (*pz.*).

Kaneko, Ayako (1942–). *Med.:* lithograph. *Ed.:* 10. *Member:* J. Print Assn.

Kaneko, Chieko (1921–). *Med.:* lithograph. *Ed.:* 20. *Member:* J. Print Assn.

Kano, Mitsuo (1933–). *Med.:* etching. *Member:* J. Print Assn., Kokuga-kai (*pz.*), independent. *Int.:* Ljubljana (*pz.*), São Paulo, Tokyo (*pz.*).

Kano, Tsugeyasu (1928–). *Med.:* woodblock. *Ed.:* 50. *Member:* J. Print Assn., other.

*Karhu, Clifton (1927–). *Med.:* woodblock. *Ed.:* 80. *Member:* J. Print Assn.

Kato, Kiyoharu. *Med.:* woodblock, etching. *Member:* other.

Kato, Kiyomi (1931–). *Med.:* lithograph, etching. *Member:* J. Print Assn. (*pz.*), independent, Shunkyokai. *Int.:* Tokyo.

Kato, Shiro. *Med.:* etching, other.

Kato, Yasu (1907–). *Med.:* woodblock. *Ed.:* 40. *Member:* J. Print Assn.

Katori, Akira. *Member:* J. Print Assn.

Katsuhiro, Tokushi (1904–). *Med.:* woodblock. *Member:* J. Print Assn., Kokuga-kai.

Katsumoto, Fujio (1925–). *Med.:* etching, stencil. *Ed.:* 30. *Member:* other. *Int.:* Paris.

Kawachi, Mieko. *Med.:* woodblock. *Member:* J. Print Assn.

Kawachi, Nariyuki. *Med.:* woodblock, etching. *Member:* J. Print Assn.

*Kawada, Kan (1927–). *Med.:* stencil. *Ed.:* 50. *Member:* other.

Kawada, Shigeo (1941–). *Med.:* silkscreen, other. *Ed.:* 100. *Int.:* Krakow.

Kawaguchi, Yasuhiko. *Med.:* woodblock, lithograph, silkscreen, etching.

*Kawahara, Hideo (1911–). *Med.:* woodblock, lithograph. *Ed.:* 20. *Member:* J. Print Assn.

Kawahara, Ryuji. *Member:* J. Print Assn.

Kawakami, Chosei (?–1972). *Med.:* woodblock.

Kawakami, Kureshio (1901–).

Kawakami, Sumio (1895–). *Med.:* woodblock. *Member:* J. Print Assn., Kokuga-kai.

Kawanishi, Hide (1894–1965). *Member:* J. Print Assn., Kokuga-kai.

Kawanishi, Yuzaburo (1923–). *Med.:* woodblock. *Member:* J. Print Assn., Kokuga-kai (*pz.*).

Kawano, Kaori (1916–). *Med.:* woodblock, silkscreen, other. *Member:* Kokuga-kai. *Int.:* Ljubljana.

Kawarai, Akiko. *Med.:* lithograph. *Ed.:* 20. *Member:* J. Print Assn.

Kazuki, Yasuo. *Med.:* lithograph. *Ed.:* 100.

*Kida, Yasuhiko (1944–). *Med.:* woodblock. *Ed.:* 25.

Kidokoro, Sho (1934–). *Med.:* woodblock. *Ed.:* 30. *Member:* J. Print Assn. *Int.:* Paris, São Paulo.

Kiguchi, Keizo (1941–). *Med.:* lithograph.

Kimura, Kihachi. *Member:* J. Print Assn.

*Kimura, Kosuke (1936–). *Med.:* photo intaglio, lithograph, silkscreen. *Ed.:* 60. *Int.:* CCAC (*pz.*), Krakow (*pz.*), Ljubljana (*pz.*), São Paulo, Tokyo.

*Kimura, Risaburo (1924–). *Med.:* lithograph, silkscreen, etching. *Ed.:* 30, 250. *Int.:* Tokyo. Lives in America.

Kimura, Shigeo (1929–). *Med.:* silkscreen, etching, other. *Member:* Kokuga-kai.

Kimura, Shigeru (1929–). *Med.:* etching. *Int.:* Ljubljana.

*Kinoshita, Tomio (1923–). *Med.:* wood engraving, woodblock, other. *Ed.:* 50. *Member:* J. Print Assn.

Kitagawa, Tamiji (1894–). *Med.:* woodblock, lithograph, etching. Studied abroad.

*Kitaoka, Fumio (1918–). *Med.:* wood engraving, woodblock. *Ed.:* 100. *Member:* J. Print Assn. *Int.:* São Paulo, Tokyo. Studied abroad.

Kiyota, Yuji. *Med.:* woodblock. *Ed.:* 20.

Kiyozuka, Noriko (1940–). *Med.:* other. *Ed.:* 15. *Member:* J. Print Assn.

Kobashi, Yasuhide (1931–).

Kobayashi, Donge (1927–). *Med.:* lithograph, etching. *Member:* Shunkyokai. *Int.:* Tokyo. Studied abroad.

Kobayashi, Kiyoko (1947–). *Med.:* lithograph. *Ed.:* 25. *Member:* J. Print Assn.

Koda, Mieko. *Member:* Shunkyokai.

Kodama, Mitsuo. *Member:* other.

Koguchi, Katsumi. *Member:* J. Print Assn.

*Koike, Nobuko (1939–). *Med.:* etching. *Ed.:* 35. *Member:* J. Print Assn.

*Koike, Nobuko (*continued*). Studied abroad. Lives abroad.

Koizumi, Shigeko. *Member:* J. Print Assn.

Kojima, Nobuaki. *Member:* independent. Lives abroad.

Komai, Tetsuro (1920–). *Med.:* other. *Member:* J. Print Assn., Shunkyokai.
Int.: Lugano, São Paulo (*pz.*), Tokyo. Studied abroad.

*Kono, Yoshio (1921–). *Med.:* silkscreen. *Ed.:* 30.

Kosaka, Gajin (1877–1953).

*Kosaka, Ryuji (1912–72). *Med.:* woodblock. *Ed.:* 100. *Member:* Kokuga-kai.

*Kubo, Akira (1926–). *Med.:* silkscreen.

Kubota, Kazuko. *Med.:* lithograph.

Kumagai, Goro (1932–). *Med.:* woodblock. *Ed.:* 75. *Member:* Kokuga-kai.
Int.: Tokyo.

Kunimatsu, Asuka (1947–). *Med.:* silkscreen.

*Kunishima, Seiji (1937–). *Med.:* silkscreen. *Ed.:* 15.

Kurata, Junji (1951–).

Kuriyama, Shigeru. *Med.:* woodblock. *Member:* J. Print Assn.

Kuroki, Sadao (1909–). *Med.:* woodblock. *Ed.:* 20.

*Kurozaki, Akira (1937–). *Med.:* woodblock. *Member:* J. Print Assn.,
Kokuga-kai. *Int.:* Krakow (*pz.*), Ljubljana, Paris, Tokyo (*pz.*).

*Kusaka, Kenji (1936–). *Med.:* woodblock. *Int.:* Ljubljana, São Paulo,
Tokyo (*pz.*).

Kusuda, Kiyoko.

Kutayama, Mika (1935–). *Med.:* etching. *Ed.:* 90. *Int.:* Tokyo. Studied
abroad.

Mabuchi, Toru (1920–). *Med.:* woodblock. *Member:* other. *Int.:* Tokyo.

Maeda, Josaku. *Member:* other.

Maeda, Masao (1904–). *Med.:* woodblock. *Member:* J. Print Assn., Kokuga-
kai. *Int.:* Tokyo.

Maeda, Morikazu (1932–). *Med.:* woodblock. *Ed.:* 40. *Member:* J. Print
Assn.

Maeda, Toshiro (1904–). *Med.:* woodblock, other. *Member:* J. Print Assn.,
Shunkyokai. *Int.:* Tokyo.

Maekawa, Senpan (1888–1960). *Med.:* woodblock. *Int.:* Tokyo.

Maita, Fumio. *Med.:* woodblock. *Ed.:* 10. *Member:* J. Print Assn.

*Maki, Haku (1924–). *Med.:* woodblock, other. *Ed.:* 200. *Member:* J.
Print Assn. *Int.:* Tokyo.

Maki, Jun'ichi (1928–). *Med.:* woodblock, etching.

Makino, Yasuzo. *Med.:* lithograph. *Ed.:* 10.

Masuda, Yoichi. *Med.:* etching.

Masuda, Yoshinobu (1905–). *Member:* J. Print Assn.

*Matsubara, Naoko (1937–). *Med.:* woodcut.

*Matsubara, Tatsuo (1941–). *Med.:* silkscreen.

Matsuda, Akio. *Med.:* woodblock, stencil, other. *Ed.:* 50.

Matsuda, Seiichi (1932–).
*Matsumoto, Akira (1936–). *Med.:* woodblock, intaglio, silkscreen. *Ed.:* 30. *Member:* independent. *Int.:* Krakow, Ljubljana, Paris.
Matsumura, Sadaiku (1936–). *Med.:* silkscreen, other. *Ed.:* 75. *Int.:* Krakow.
Matsuoka, Toshiyuki. *Med.:* silkscreen. *Ed.:* 30. *Member:* J. Print Assn.
*Matsutani, Takesada (1937–). *Med.:* lithograph, silkscreen, intaglio, etching. *Ed.:* 50. *Member:* other. *Int.:* CCAC (*pz.*), Paris, Tokyo. Studied abroad.
Minami, Keiko (1911–). *Med.:* etching. *Member:* J. Print Assn. *Int.:* Tokyo. Studied abroad. Lives abroad.
*Minomura, Yoshio (1942–). *Med.:* etching.
*Mishio, Fuki (1931–). *Med.:* silkscreen. *Ed.:* 30.
Mitsui, Eiichi. *Med.:* lithograph. *Ed.:* 20. *Member:* Shunkyokai.
Miura, Jiro. *Med.:* etching. *Ed.:* 20. *Member:* J. Print Assn.
Miura, Kiyoshi. *Med.:* woodblock, lithograph, etching, stencil.
Miyao, Shigeo (1902–).
*Miyashita, Tokio (1930–). *Med.:* woodblock, intaglio, etching. *Member:* J. Print Assn. *Int.:* Ljubljana, São Paulo, Tokyo (*pz.*).
Miyata, Sugako.
Miyoshi, Toshihiro (1940–). *Member:* J. Print Assn.
Miyoshi, Yukiko.
*Mizufune, Rokushi (1912–). *Med.:* woodblock. *Ed.:* 50. *Member:* J. Print Assn. *Int.:* Tokyo.
Mori, Manabu (1925–). *Med.:* woodblock, stencil, other. *Ed.:* 50. *Member:* independent. *Int.:* Tokyo (*pz.*).
Mori, Takayuki. *Med.:* woodblock. *Ed.:* 50.
Mori, Yasu (1922–). *Med.:* woodblock. *Member:* Kokuga-kai. *Int.:* Tokyo.
*Mori, Yoshitoshi (1898–). *Med.:* stencil. *Ed.:* 50. *Member:* independent. *Int.:* Tokyo.
Morimura, Iichi (1926–). *Member:* other. *Int.:* Tokyo.
Morino, Mayumi (1941–). *Med.:* stencil. *Ed.:* 30. *Member:* J. Print Assn.
*Morishima, Isamu (1935–). *Med.:* lithograph, silkscreen, etching. *Ed.:* 30.
Morita, Mutsumi (1935–). *Med.:* stencil. *Ed.:* 85. *Member:* other.
*Morozumi, Osamu (1949–). *Med.:* woodblock. *Ed.:* 40.
Motonaga, Sadamasa (1922–). *Med.:* silkscreen. *Ed.:* 30. Studied abroad.
Motoyama, Keiko.
Motoyama, Michiko.
*Munakata, Shiko (1903–). *Med.:* woodcut, woodblock, etching. *Member:* Kokuga-kai. *Int.:* Lugano, São Paulo (*pz.*), Tokyo, Venice.
Murai, Masanari (1905). *Med.:* woodblock, lithograph. *Ed.:* 20. *Member:* other. *Int.:* Tokyo (*pz.*). Studied abroad.

*Nagai, Kazumasa (1929–). *Med.:* woodblock, zinc relief, stencil. *Ed.:* 20. *Member:* independent. *Int.:* Ljubljana, Tokyo.

Nagase, Yoshio (1891–). *Med.:* woodblock, lithograph, silkscreen, etching, stencil, other. *Member:* independent. *Int.:* Tokyo. Studied abroad.

Nagatani, Etsuko. *Med.:* lithograph. *Member:* J. Print Assn.

Nakabayashi, Tadayoshi (1937–). *Med.:* stencil. *Member:* J. Print Assn. *Int.:* Ljubljana, Tokyo.

Nakagawa, Yuzaburo. *Med.:* woodblock.

Nakamura, Yutaka.

Nakao, Yoshitaka (1911–). *Med.:* lithograph. *Member:* J. Print Assn. *Int.:* Tokyo.

Nakatsuji, Etsuko. *Med.:* silkscreen. *Ed.:* 30. Studied abroad.

*Nakayama, François (Masami; 1898–). *Med.:* etching. *Member:* J. Print Assn. *Int.:* Tokyo. Studied abroad.

*Nakayama, Tadashi (1927–). *Med.:* woodblock, lithograph, silkscreen. *Ed.:* 75. *Int.:* Krakow, Tokyo.

Nimura, Yuko (1943–).

Nishi, Tadashi. *Med.:* woodblock, silkscreen, other. *Int.:* Paris.

Nishigai, Kazuko (1932–). *Med.:* other. *Ed.:* 30. *Member:* J. Print Assn. *Int.:* Tokyo.

Nishihara, Kazuko (1943–). *Med.:* silkscreen. *Ed.:* 20.

Nishikawa, Fujitaro. *Member:* J. Print Assn.

Nishimaki, Kayako. *Med.:* lithograph, etching. *Ed.:* 30. *Member:* J. Print Assn.

Nishizawa, Shizuo (1912–). *Med.:* etching. *Ed.:* 30. *Member:* J. Print Assn.

*Noda, Tetsuya (1940–). *Med.:* woodblock, silkscreen. *Ed.:* 30. *Member:* independent. *Int.:* Krakow (*pz.*), Ljubljana, Paris, São Paulo, Tokyo (*pz.*), Venice.

Noma, Denji (1935–). *Med.:* etching. *Ed.:* 25. *Member:* other. Studied abroad.

Noma, Yoshiko (1934–). *Med.:* woodblock, etching. *Int.:* Ljubljana, Tokyo.

Nomura, Hiroshi (1923–). *Med.:* woodblock, lithograph, etching. *Ed.:* 20. *Int.:* Ljubljana, Lugano, Tokyo.

Nomura, Kozo. *Member:* Shunkyokai.

Nomura, Kunio.

Nonaka, Yuri (1938–). *Med.:* etching. *Member:* independent. *Int.:* Tokyo.

*Nozaki, Shinjiro (1923–). *Med.:* silkscreen.

Obata, Tsutomu. *Med.:* other. *Ed.:* 10. *Member:* J. Print Assn.

Oda, Jo (1936–). *Med.:* other. *Ed.:* 50. *Member:* other. *Int.:* Tokyo. Studied abroad.

*Oda, Mayumi (1941–). *Med.:* silkscreen, stencil, other. *Ed.:* 50. Studied abroad. Lives abroad.

Oda, Shigeru. *Med.:* etching. Studied abroad.

Ogata, Issei. *Med.:* etching. *Ed.:* 30. *Int.:* Krakow, Ljubljana (*pz.*), Paris. Studied abroad.

Ogawa, Tatsuhiko. *Member:* J. Print Assn.
Oguchi, Masuichi (1919–). *Med.:* silkscreen, other. *Ed.:* 20. *Member:* other.
Int.: Tokyo.
Ohashi, Hiroaki. *Med.:* woodblock. *Ed.:* 20. *Member:* Kokuga-kai.
*Ohba, Masao (1928–). *Med.:* paper screen, etching, other. *Ed.:* 150.
Member: other.
*Okamoto, Shinjiro (1933–). *Med.:* woodblock, silkscreen. *Ed.:* 50. *Int.:*
Tokyo. Studied abroad.
*Okamoto, Shogo (1920–). *Med.:* etching. *Ed.:* 80. *Member:* J. Print Assn.
Omori, Shikiko. *Member:* J. Print Assn.
Omoto, Yasushi. *Med.:* woodblock, silkscreen. *Member:* J. Print Assn.
Onda, Akio. *Med.:* woodblock. *Ed.:* 20.
Ono, Tadashige (1909–). *Med.:* woodblock. *Int.:* Tokyo.
*Onogi, Gaku (1924–). *Med.:* silkscreen. *Ed.:* 10.
*Onosato, Toshinobu (1912–). *Med.:* silkscreen. *Ed.:* 100. *Member:* other.
Int.: Tokyo, Venice.
Osakabe, Tatsuo (1932–). *Med.:* woodblock, etching, stencil.
Ota, Koshi. *Member:* J. Print Assn.
*Ouchi, Makoto (1926–). *Med.:* etching. *Ed.:* 60. *Member:* J. Print Assn.
Ozaku, Seishi (1938–). *Med.:* lithograph. *Member:* J. Print Assn.

Petit, Gaston (1930–). *Med.:* woodblock, silkscreen, other. *Ed.:* 20.

Saito, Juichi (1931–). *Med.:* etching, other. *Ed.:* 30. *Int.:* Ljubljana, Paris,
Tokyo. Studied abroad.
*Saito, Kiyoshi (1907). *Med.:* woodblock. *Ed.:* 100, 200. *Member:* Kokuga-
kai. *Int.:* São Paulo (*pz.*).
*Saito, Ryo (1941–). *Med.:* silkscreen. *Ed.:* 30. *Member:* other. *Int.:*
Krakow. Studied abroad.
Saito, Satoshi. *Med.:* silkscreen.
Saito, Yoshishige. *Member:* other.
Sakaguchi, Minoru. *Member:* J. Print Assn.
Sakakibara, Nobukichi. *Med.:* etching. *Ed.:* 20. *Member:* J. Print Assn.
Sakamoto, Hironori. *Member:* J. Print Assn.
Sakamoto, Isamu (1931–). *Med.:* woodblock. *Ed.:* 80. *Member:* J. Print
Assn.
*Sakamoto, Koichi (1932–). *Med.:* etching, other. *Ed.:* 50. *Member:* J.
Print Assn.
Sakazume, Atsuo. *Med.:* other.
Sakurai, Hisashi. *Med.:* lithograph, silkscreen. *Member:* J. Print Assn.
*Sarashina, Shu (1935–). *Med.:* etching, other. *Ed.:* 10. *Member:* J. Print
Assn.
*Sasajima, Kihei (1901–). *Med.:* woodblock. *Ed.:* 50. *Member:* Kokuga-kai.
Int.: São Paulo, Tokyo.

*Sasaki, Asako (1939–). *Med.:* lithograph, silkscreen, etching. Studied abroad.

*Sato, Ado (1936–). *Med.:* silkscreen. Lives abroad.

Sato, Hiromu (1923–). *Med.:* woodblock, stencil. *Member:* J. Print Assn., Kokuga-kai. *Int.:* Tokyo.

Sato, Nobuo (1926–). *Med.:* other. *Ed.:* 75. *Member:* J. Print Assn., Kokuga-kai. *Int.:* Krakow.

*Sawada, Tetsuro (1933–). *Med.:* silkscreen.

Seimiya, Naobumi (1917–). *Med.:* woodblock. *Member:* Shunkyokai.

Seino, Katsumi.

*Sekine, Yoshio (1922–). *Med.:* silkscreen. *Ed.:* 100. *Member:* independent.

*Sekino, Jun'ichiro (1914–). *Med.:* woodblock, lithograph, etching. *Ed.:* 50. *Member:* J. Print Assn. *Int.:* Ljubljana (*pz.*), Lugano, Tokyo.

Senda, Takashi. *Med.:* silkscreen. *Ed.:* 50. *Member:* independent. Studied abroad.

Serizawa, Keisuke.

*Shibuya, Eiichi (1928–). *Med.:* etching. *Ed.:* 50. *Member:* J. Print Assn. Studied abroad.

Shima, Kuniichi (1935–). *Member:* independent. *Int.:* Krakow, Paris, Tokyo.

Shimizu, Yoshiyuki. *Med.:* lithograph, silkscreen. *Member:* J. Print Assn.

Shimosawaki, Hachiro (1901–). *Med.:* woodblock.

Shimotani, Chihiro (1934–). *Med.:* silkscreen. *Member:* independent.

Shimoyama, Tsutomu (1945–).

Shimozawa, Kin'uchiro (1901–). *Med.:* woodblock. *Member:* Kokuga-kai. *Int.:* Tokyo.

*Shinagawa, Takumi (1908–). *Med.:* woodblock, stencil. *Ed.:* 30. *Member:* Kokuga-kai. *Int.:* Tokyo.

*Shinoda, Toko (1913–). *Med.:* lithograph.

Shinohara, Ushio (1932–).

Shirai, Akiko (1935–). *Med.:* etching, other. *Ed.:* 50. *Int.:* Tokyo. Studied abroad. Lives abroad.

Shishido, Tokuko (1930–). *Med.:* woodblock, lithograph, etching. *Member:* J. Print Assn. *Int.:* Tokyo. Studied abroad.

*Sora, Mitsuaki (1933–). *Med.:* woodblock. *Ed.:* 80. Studied abroad.

Suga, Takako. *Member:* J. Print Assn.

*Sugai, Kumi (1919–). *Med.:* silkscreen, lithograph. *Int.:* Krakow, Ljubljana, São Paulo, Tokyo (*pz.*), Venice. Studied abroad. Lives abroad.

Sugano, Yo (1919–). *Med.:* etching. *Ed.:* 30. *Member:* independent. *Int.:* Tokyo.

Suzuka, Yoshiyasu (1947–). *Member:* independent.

Suzuki, Arei. *Member:* J. Print Assn.

Suzuki, Chikara. *Member:* J. Print Assn.

Suzuki, Kanji (1921–). *Med.:* woodblock. *Ed.:* 20. *Member:* J. Print Assn. *Int.:* Krakow.

Suzuki, Kenji (1906–). *Med.:* woodblock.

Tagado, Gaku.

*Tajima, Hiroyuki (1911–). *Med.:* woodblock. *Ed.:* 50. *Member:* J. Print Assn. *Int.:* Tokyo.

Tajima, Masahiko. *Med.:* silkscreen. *Member:* J. Print Assn.

*Takabe, Taeko (1941–). *Med.:* etching. *Ed.:* 50. *Member:* J. Print Assn. *Int.:* Krakow.

Takagi, Shiro (1934–). *Med.:* woodblock. *Ed.:* 50. *Int.:* Krakow (*pz.*), Paris, São Paulo, Tokyo.

Takahashi, Isao. *Med.:* silkscreen, stencil, other. *Member:* J. Print Assn. Lives abroad.

Takahashi, Junko (1927–). *Med.:* woodblock, etching. *Ed.:* 50. *Member:* J. Print Assn. *Int.:* Paris, Tokyo.

Takahashi, Katsuyoshi.

*Takahashi, Rikio (1917–). *Med.:* woodblock. *Ed.:* 30. *Int.:* Krakow, Tokyo. Studied abroad.

Takahashi, Shin'ichi (1917–). *Med.:* woodblock. *Ed.:* 50. *Member:* J. Print Assn. Studied abroad.

Takahashi, Shozo (1929–). *Med.:* etching. *Ed.:* 20. *Member:* Kokuga-kai.

Takamatsu, Jiro (1936–). *Member:* independent.

Takao, Chiyomitsu (1927–). *Med.:* other. *Ed.:* 30. *Member:* J. Print Assn.

Takaoka, Matsuo (1945–). *Med.:* silkscreen. *Ed.:* 15.

Takayanagi, Yutaka. *Med.:* other. *Ed.:* 100. *Member:* J. Print Assn.

Takeda, Kazuko. *Med.:* other. *Int.:* Tokyo.

Takeda, Takeo. *Med.:* woodblock. *Ed.:* 50. *Member:* Shunkyokai.

Takei, Takeo (1894–). *Med.:* woodblock. *Member:* J. Print Assn. *Int.:* Tokyo.

Takidaira, Jiro (1921–). *Med.:* woodblock. *Member:* other.

Tamagami, Tsuneo (1923–). *Med.:* woodblock, etching. *Int.:* Tokyo.

Tamai, Chuichi. *Member:* J. Print Assn.

*Tamura, Fumio (1941–). *Med.:* lithograph. *Ed.:* 30. *Member:* J. Print Assn. *Int.:* Krakow, Tokyo.

Tanabe, Kazuro (1937–). *Med.:* silkscreen. *Ed.:* 30. *Member:* J. Print Assn.

Tanaka, Hisaji.

Tanaka, Masaaki (1947–).

*Tanaka, Ryohei (1933–). *Med.:* etching. *Ed.:* 100. *Member:* J. Print Assn.

Tanaka, Susumu. *Med.:* etching. Studied abroad.

Tanami, Miwako. *Med.:* other. *Ed.:* 30. *Member:* Shunkyokai.

Tanatani, Isao (1943–). *Med.:* etching. *Ed.:* 20. *Member:* J. Print Assn.

Taniguchi, Shigeru (1948–).

Tanushi, Makoto (1942–).

Terajima, Katsuji.

*Teshima, Keizaburo (1935–). *Med.:* woodcut. *Ed.:* 50.

Tobari, Hiroshi (1936–). *Member:* other.

Toshigi, Junko (1932–). *Med.:* silkscreen. *Ed.:* 30. *Member:* J. Print Assn. *Int.:* Tokyo.

*Toda, Yoko (1944–). *Med.:* silkscreen. *Ed.:* 30. Studied abroad. Lives abroad.

*Togashi, Minoru (1931–). *Med.:* woodblock, copperplate intaglio. *Ed.:* 30. *Int.:* Paris. Studied abroad.

Tokuriki, Tomikichiro (1902–). *Med.:* woodblock.

*Tomihari, Hiroshi (1936–). *Med.:* woodblock.

*Tomita, Fumio (1934–). *Med.:* silkscreen. *Ed.:* 10. *Member:* J. Print Assn. *Int.:* Krakow.

Tomozawa, Yasuo. *Med.:* woodblock. *Ed.:* 30. *Member:* J. Print Assn.

*Toneyama, Kojin (1921–). *Med.:* woodblock, lithograph. *Ed.:* 50. *Member:* J. Print Assn. *Int.:* Tokyo. Studied abroad.

Tsubota, Masahiko (1947–). *Med.:* silkscreen. *Ed.:* 20.

Tsuchimochi, Kazuo.

Tsuji, Masato. *Member:* other.

*Tsukagoshi, Genshichi (1922–). *Med.:* silkscreen, stencil. *Ed.:* 70.

Tsukamoto, Tetsu. *Member:* J. Print Assn.

Tsukimizato, Shigeru (1928–). *Med.:* woodblock, etching.

Tsuruoka, Yoh (1941–). *Med.:* etching. *Member:* J. Print Assn.

Uchima, Ansei (1921–). *Med.:* woodblock. *Int.:* São Paulo, Tokyo. Lives abroad.

Ueda, Gagyu (1921–). *Med.:* woodblock. *Ed.:* 100.

Ueki, Sumiko. *Med.:* woodblock. *Ed.:* 50. *Member:* J. Print Assn.

Ueno, Makoto (1909–). *Med.:* woodblock. *Member:* J. Print Assn.

Ueno, Nagao. *Med.:* woodblock. *Member:* J. Print Assn.

*Ueno, Norio (1932–). *Med.:* lithograph. *Member:* other.

Ueno, Seisaku (1911–). *Med.:* lithograph, etching. *Member:* other. *Int.:* Tokyo.

Ueno, Shu. *Member:* J. Print Assn.

*Unno, Mitsuhiro (1939–). *Med.:* woodblock. *Ed.:* 100. *Member:* J. Print Assn.

Uozumi, Ioyo. *Med.:* etching. *Ed.:* 30. *Member:* independent.

*Ushiku, Kenji (1922–). *Med.:* woodblock, etching. *Member:* J. Print Assn. *Int.:* Tokyo.

*Ushiku, Mari (1924–). *Med.:* stencil. *Member:* J. Print Assn.

Wakae, Kanji (1944–). *Med.:* silkscreen, other. *Member:* J. Print Assn. *Int.:* Krakow.

Wakayama, Yasoji (1903–). *Med.:* stencil, other. *Ed.:* 11. *Member:* J. Print Assn.

Wakita, Aijiro. *Member:* independent.

Watanabe, Mitsuru. *Member:* J. Print Assn.

*Watanabe, Sadao (1913–). *Med.:* stencil. *Ed.:* 70. *Member:* Kokuga-kai. *Int.:* Tokyo.

Watanabe, Yuji (1941–). *Med.:* woodblock. *Ed.:* 30. *Member:* J. Print
Assn.

*Watarai, Junsuke (1936–). *Med.:* etching. *Ed.:* 50. *Member:* J. Print Assn.
Studied abroad.

Yamada, Mitsuo. *Med.:* woodblock, other.

Yamada, Shin'ichi. *Member:* J. Print Assn.

Yamaguchi, Gen (1903–). *Med.:* woodblock. *Member:* Kokuga-kai. *Int.:*
Lugano (*pz.*), Tokyo (*pz.*).

Yamaguchi, Hirokazu (1940–). *Med.:* lithograph, silkscreen. *Ed.:* 15.
Member: J. Print Assn. Studied abroad.

*Yamaguchi, Osamu (1918–). *Med.:* stencil, other. *Ed.:* 1.

Yamaguchi, Susumu (1897–). *Member:* J. Print Assn.

*Yamanobe, Yoshio (1936–). *Med.:* etching. *Member:* J. Print Assn.

*Yamaoka, Peter (1948–). *Med.:* lithograph.

Yamaryo, Mari. *Med.:* lithograph. *Ed.:* 10.

Yamataka, Noboru (1926–).

Yamazaki, Kazuko. *Med.:* silkscreen. *Ed.:* 50.

Yanagizawa, Noriko (1940–). *Med.:* silkscreen, etching. *Ed.:* 20. *Member:*
J. Print Assn. *Int.:* Krakow. Studied abroad. Lives abroad.

Yano, Susumu.

*Yayanagi, Tsuyoshi (1933–). *Med.:* silkscreen, etching. *Ed.:* 50. *Member:*
independent. *Int.:* Ljubljana, Paris, São Paulo.

Yokoo, Tadanori (1936–). *Med.:* silkscreen.

Yoshida, Chizuko (1924–). *Med.:* woodblock. *Ed.:* 50. *Member:* J. Print
Assn.

*Yoshida, Hodaka (1926–). *Med.:* woodblock, lithograph, intaglio, silk-
screen, etching. *Ed.:* 50. *Member:* J. Print Assn. *Int.:* Krakow, Lugano
(*pz.*), Paris, São Paulo.

Yoshida, Katsuro (1943–). *Med.:* silkscreen. *Ed.:* 40. *Int.:* Krakow,
Ljubljana.

*Yoshida, Kazue (1948–). *Med.:* etching. *Ed.:* 15.

Yoshida, Masaji (1917–). *Med.:* woodblock, etching, stencil. *Int.:* Lugano,
São Paulo, Tokyo (*pz.*).

*Yoshida, Masao (1935–). *Med.:* etching. *Ed.:* 40. Studied abroad.

Yoshida, Toshi (1911–). *Med.:* woodblock, lithograph, etching. *Ed.:* 150.
Member: J. Print Assn. *Int.:* Lugano.

Yoshihara, Hideo (1931–). *Med.:* woodblock, lithograph, silkscreen, etch-
ing. *Ed.:* 75. *Member:* independent. *Int.:* Krakow, São Paulo, Tokyo.

Yoshihara, Jiro. *Member:* other.

Yoshinaka, Taizo (1928–). *Member:* other.

Yoshino, Toshio. *Med.:* silkscreen. *Ed.:* 30. *Member:* J. Print Assn.

Yoshioka, Hiroaki (1942–).

*Yuki, Rei (1928–). *Med.:* woodblock. *Ed.:* 50. *Member:* J. Print Assn.

The "weathermark" identifies this book as a production of John Weatherhill, Inc., publishers of fine books on Asia and the Pacific. Supervising editors: Meredith Weatherby and Rebecca Davis. Book design and typography: Meredith Weatherby. Layout of illustrations: Frances Blakemore. Production supervisor: Mitsuo Okado. Composition: General Printing Co., Yokohama. Text printing and offset platemaking and printing: Kinmei Printing Co., Tokyo. Binding: Makoto Binderies, Tokyo. The typeface used is Bell.